IMAGES
of America

COLCHESTER

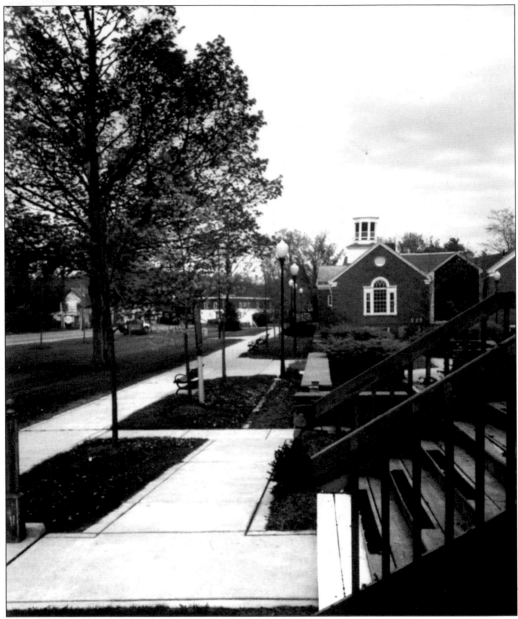

Taken from the steps of the Town Meeting House, this photograph shows the Burnham Memorial Library and the United Church of Colchester.

IMAGES
of America

COLCHESTER

Inge Schaefer

ARCADIA

First published 2003

Published by Arcadia Publishing,
an imprint of Tempus Publishing Inc.
Portsmouth NH, Charleston SC, Chicago,
San Francisco

Printed in Great Britain

Library of Congress Catalog Card Number: 2003110392

For all general information, contact Arcadia Publishing:
Telephone 843-853-2070
Fax 843-853-0044
E-mail sales@arcadiapublishing.com
For customer service and orders:
Toll-free 1-888-313-2665

Visit us on the Internet at www.arcadiapublishing.com

On the cover: The Colchester Lighthouse is shown in the late 1800s. (Courtesy of the Shelburne Museum.)

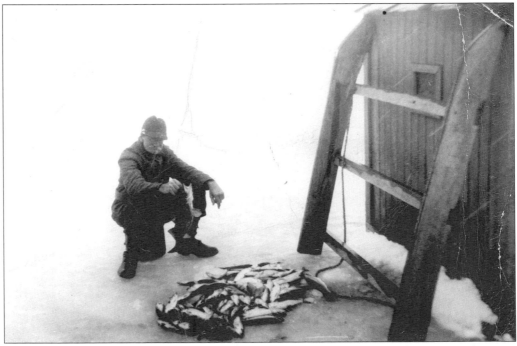

William Coates is ice fishing on Malletts Bay in the early 1900s. (Courtesy of the David Coates family collection.)

CONTENTS

Acknowledgments 6

Introduction 7

1. Colchester Village 9

2. Clay Point 41

3. Malletts Bay 49

4. Fort Ethan Allen 85

5. Winooski 101

6. The Ties That Bind 109

ACKNOWLEDGMENTS

Imagine rowing up the river in a canoe with American Indian guides, axes, and club seeking the "Yorkers" who were settling on the "falls" you had decided would better be settled by you. Once the Yorkers are persuaded to your way of thinking, imagine clearing the land, building a dam, spreading into the surrounding forest lands to farm, and helping to build what is today the second largest single community in the state of Vermont. Such are the kind of facts found in these resources: *Colchester, Vermont: From Ice Cap to Interstate*, by Ruth Wright; *Colchester Center: The Evolution of a Village*, by Kenneth A. Degree; *Look Around Colchester and Milton, Vermont*, by the Chittenden County Historical Society; *The Great Falls on the Onion River: A History of Winooski, Vermont*, by Vincent Edward Feeney; *Atlas of Chittenden County*, by F.W. Beers; and in the memories of the many Colchesterites who have so willingly offered their family photographs for this book. I have chosen to acknowledge those folks individually, when available, in the captions following the images. Their memories bring the images to life. The smiles and the sparkle in their eyes as they remember a loved one or an unforgettable moment has made this book a joy to prepare. Thank you all, and thanks to all the photographers.

For making this task easier, I thank Shawn Breyer of St. Michael's College; Brian Costello of Local Motion; Sr. Irene Duchesneau, the Fanny Allen campus of Fletcher Allen Health Care; John Gant for his historical article on Fort Ethan Allen; Carol Reichard of the Colchester Historical Society; Bob and Jeannie Picher of the Winooski Historical Society; Eben Wolcott and Joyce Sweeney for reviewing the draft manuscript; Julie Weaver for proofreading; and my husband, who helps me whenever and however he can.

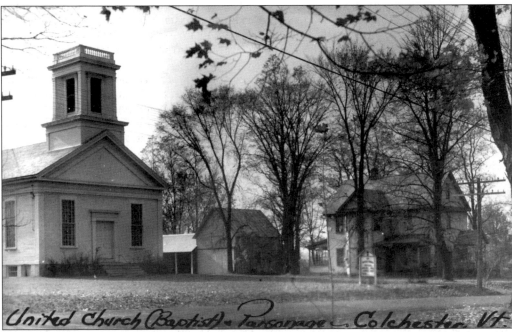

United Church (Baptist) Parsonage, Colchester Vt

The Baptist church, with its parsonage to the right, was built in 1861 and is located on Main Street in Colchester Village.

INTRODUCTION

Diversity defines Colchester. From its sandy soils in Malletts Bay to its fine clays found in the Clay Point area to its wetlands and rocky hills, Colchester holds as much contrast in its topography and geology as it does in its assortment of waterways. The Winooski and Lamoille Rivers border the town on the north and south, and also to the north lies the breathtaking Colchester Pond. To the southwest lies Colchester's jewel, Malletts Bay, the state's largest bay and part of Lake Champlain, the state's largest lake. With 30 miles of lakeshore, it is Lake Champlain that is the town's mainstay.

Colchester is one of the oldest communities in the state, having been chartered on June 7, 1763. In the rush of issuing charters—nine on that day alone—the name of Burling, for 10 of the grantees, was inadvertently assigned to the area south of the mouth of the Winooski River or Burlington. The *Vermont Historical Quarterly* of 1953 conjectures that the town was named for William de Nassau Zulestein, who was secretary of state during the reign of King George III and lived in Colchester, England. What luck not to have the town's name be Zulestein! All 66 proprietors on the charter were not interested in settling in this area, but instead bought the tract of land on speculation.

Another speculator was Ira Allen, who after purchasing land in the Rutland area with his inheritance, came north as a surveyor and arrived in Colchester in 1772. Allen became Colchester's first town clerk and treasurer, as well as its most important landowner, buying 15,000 of the town's 23,000 acres. The first family to live in Colchester was the Remember Bakers, with whom Allen lived. Years later, Allen became the founder of the University of Vermont and a founding father of the state of Vermont. To finance his plan to build a canal from Vermont to Canada, Allen went to Europe, leaving behind his mortgaged land. Returning several years later, he found his land sold as a result of defaulted tax sales. This allowed settlers to move into the wilderness areas of Colchester. The lives of Ira Allen, his brother Ethan, the Baker family, and Mallet—the independent, rogue sea captain—could easily fill a movie screen with drama, excitement, and adventure that were a fitting start for Colchester, now Vermont's second largest single community.

William Munson was in Colchester for the first town meeting of record on March 18, 1793. The last Munson, Walter, passed away in 2000, thus ending the longest family name legacy in town, but the family home remains. In 1797, Ebenezer Wolcott built a brick house (made from the soft rose-colored clay found along the town's brooks) at the intersection of East Road and Depot Road and raised 12 children. The house and his descendants remain in Colchester. And so it began.

The rural part of town (called Colchester Center) was made up of farmers, millers, and tradesmen who lived north and away from the hustle bustle of the Winooski Falls area. A post office began in Colchester Center in 1813. Up to 14 school districts sprang up with the largest in the Winooski village area. Lake Champlain allowed sailing ships to transport white sand from Thayer Beach through the Champlain canal; lumber was shipped by schooner to Hudson River markets; mined bog iron was carried across the lake. Friction between the residents of the rural areas and the factory and mill workers of the Winooski Falls area (woolen mills came later) was inevitable, and in 1922, Winooski split away from Colchester to become a city.

A phenomenon somewhat unique to Colchester is its lack of a downtown area. This may have resulted from the industrial, commercial nature of Winooski Falls drawing rural residents to its downtown to do their shopping and conduct business. With 37 square miles, the size of Colchester also may have prohibited such development in any one place. Colchester Center at one time did have the town's municipal office, post office, and public library, along with two prominent churches. The churches have since united under one roof; the town clerk's office moved to Blakely Road; and a new post office was built on Malletts Bay Avenue in 1978.

Industrial-commercial areas now exist by exit 16 off Route 89, at Fort Ethan Allen, and in Malletts Bay. Agriculture remains an important component of the town with dairy, sheep, vegetable, and egg farming found in all but one area. Horse stables, sugaring, honey, and horticultural enterprises add to the agrarian nature of the town.

Colchester has four distinct areas, and thus this book is separated into chapters describing those areas—Colchester Village, Clay Point, Malletts Bay, and Fort Ethan Allen. While diversity defines Colchester, it also brings it hope and a promise for a bright future. Colchesterites carry a bit of the adventurous spirit of the Allen boys. Some of Captain Mallet's orneriness sparks us at a town meeting, and the hardworking steadfastness of our pioneer families gives us the courage to strive to make this community that we love the best that it can be.

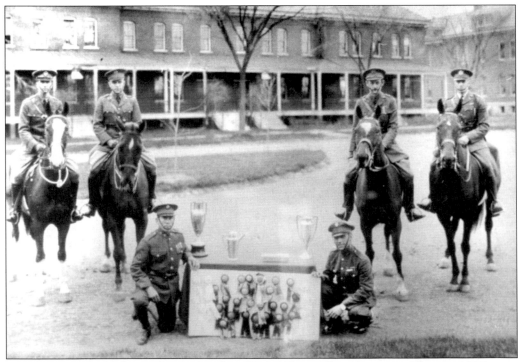

Soldiers from the 2nd or 3rd U.S. Cavalry of Fort Ethan Allen are pictured here *c.* 1917.

One

COLCHESTER VILLAGE

Until recently, the more common reference to this area of town was Colchester Center (or, as spelled on the map below, Centre). Until the late 1790s, Colchester Center was an area of densely forested wilderness with most of the town's population situated along the side of the Winooski River Falls. When new settlers arrived in the 1790s—bearing such names as Eli Baker, William Munson, Simeon Hine, and Ebenezer Wolcott—they purchased, at tax sale prices, Ira Allen's lots in the rural part of town. East Road, along with Route 7 (then known as West Road), were quickly laid out as public highways in 1797, and thus began the formation of Colchester Center.

With the town hall and later the town clerk's office and library located on Main Street, this part of town easily established its prominence as the center of Colchester. After Winooski separated from Colchester in 1922 and all but the library moved to the more centrally situated Blakely Road area, Colchester Center became more popularly known as Colchester Village. For the purposes of this book, that area extends east of Route 89, north of Severance Road and Essex (along Route 2A) to Milton. Close to 6,900 people live in this area of Colchester.

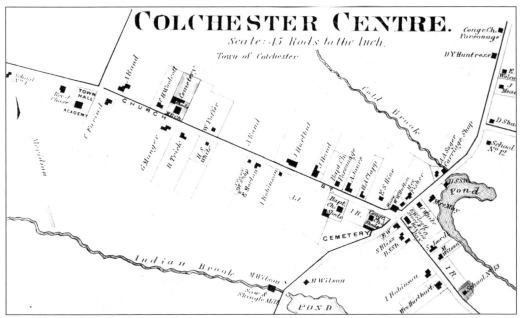

This map of Colchester Centre dates from the mid-1800s. (Courtesy of Joyce Sweeney.)

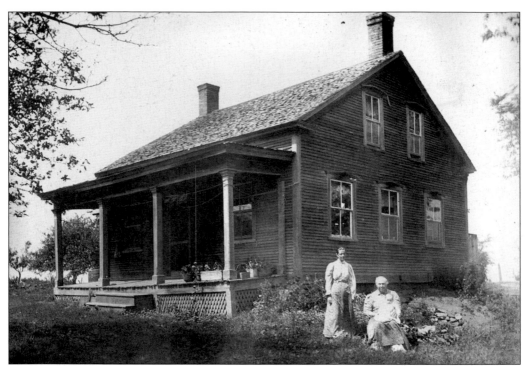

Photographs of some of the earlier homes follow. Shown here is the Cloe house, at East and Farnsworth Roads across from the McBride School. Susan Margaret Thompson Cloe poses with Adelia Farnsworth Cloe (sitting), who is holding her granddaughter Florence Adelia Cloe. (Courtesy of the Wolcott-Cloe family.)

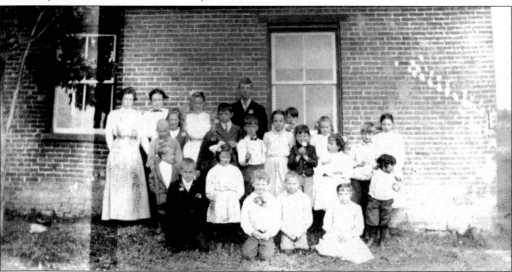

Pictured here in 1909, the McBride School (also known as District No. 9) was located at the junction of East and Farnsworth Roads. The school served students living just over in Milton as well as Colchester children. In 1858, approximately 36 students attended classes. The local school tax for District No. 9 in 1865–1866 was 30¢. The 1877 town report listed a total of $45.13 distributed to run the school, based on average daily attendance, and raised through state and local taxes. (Courtesy of the Colchester Historical Society.)

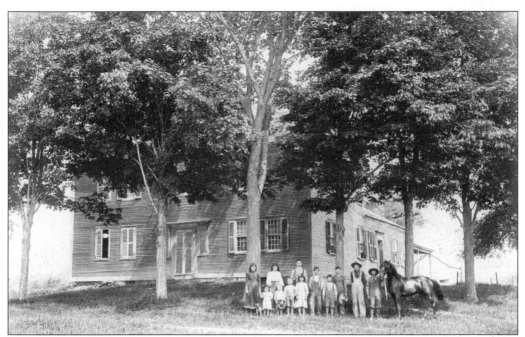

Shown c. 1900 is the Austin house, on Austin Hill Road. The family is unidentified. (Courtesy of the Wolcott-Cloe family.)

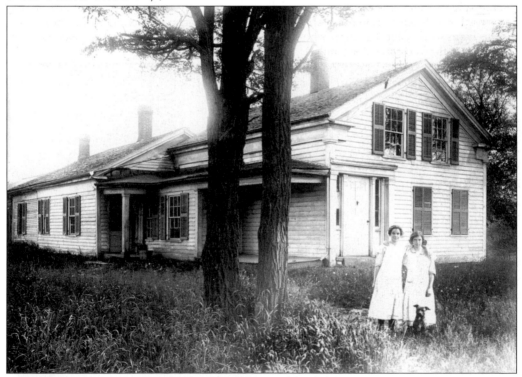

Pictured in 1911 are Persis and Florence Cloe by an East Road home that no longer stands. Florence Cloe was the mother of Eben Wolcott, who still resides on East Road. (Courtesy of the Wolcott-Cloe family.)

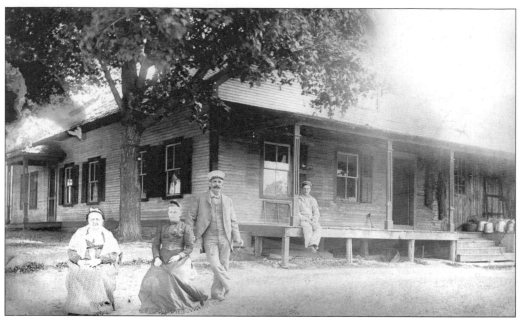

Herb Thompson stands beside his wife, Kate, and her mother in a photograph taken in the late 1800s. Their son Robert is on the porch. The house was built in the mid-1800s. (Courtesy of Thelma and Doug Wright.)

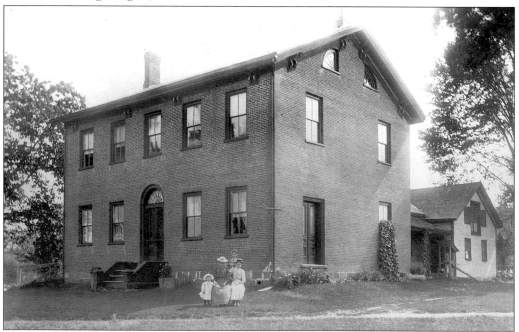

Located at the corner of East and Depot Roads, this building served as Wolcott's Tavern from 1814 to 1842 and later became the Shaw house. It had one large room on the second floor, used for dormitory-style accommodations. Like a general store, the tavern served as a center for information, debate, and local gossip. Seen here c. 1900–1905 are Lillian Wolcott with her mother, Lillia Crandall Wolcott. Standing are Max Crandall Wolcott (Eben Wolcott's father as a child) and his sister Bessie. (Courtesy of the Wolcott-Cloe family.)

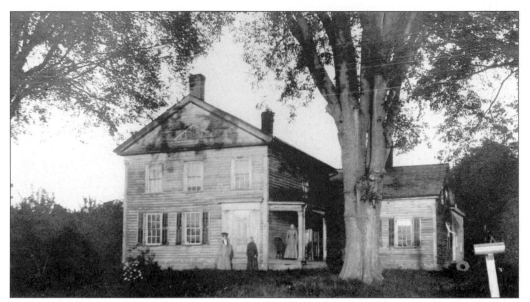

This view shows the L.L. Wolcott house, on East Road, before renovations *c*. 1913. The Wolcott name in earlier days was spelled Woolcot, but as a result of record errors or common pronunciations, names were often altered over the years. (Courtesy of the Wolcott-Cloe family.)

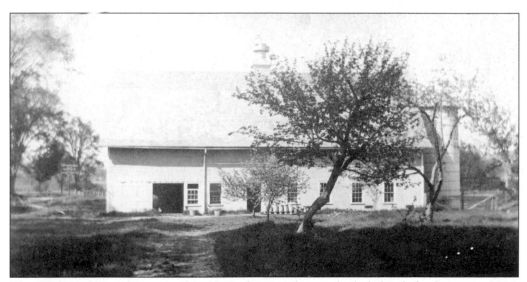

The Wolcott barn, shown in this 1940 photograph, was built behind the house in 1916. (Courtesy of the Wolcott-Cloe family.)

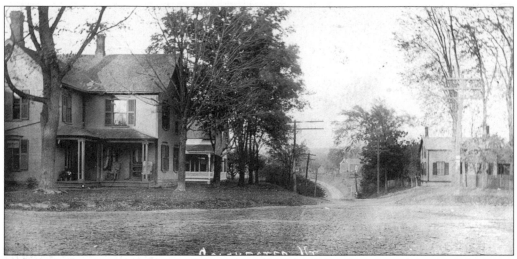

This view shows the intersection of Main Street (Route 2A) and East Road *c.* 1920. The house on the right belonged to Horace and Anna White (parents of Alta White). The house on the left was built as the Baptist parsonage after land was donated for that purpose by Mercy Spencer in 1844. The second house back on East Road was built in the late 1920s by Charles and Kathryn Bouchard. All three homes are still occupied by individual homeowners. (Courtesy of Joyce Sweeney.)

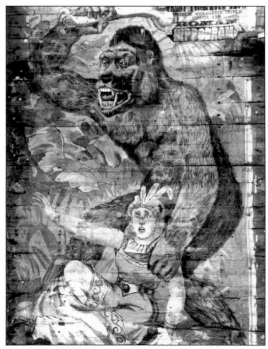

The Spencer house was built in 1844 and renovated in 1883. When the Degree family decided to install new siding in 1991, they discovered four circus posters under the siding. Used to advertise an upcoming Adam Forepaugh Circus (one of the biggest in the country at that time), the posters were found to be in excellent condition. The painstaking job of removing the poster-covered planks was done by the Shelburne Museum in just four days. (Courtesy of Harold and Gladys Degree.)

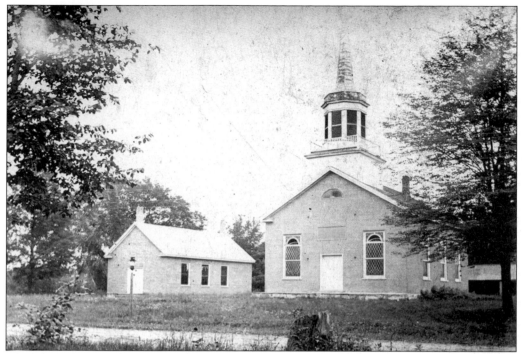

The brick church on Main Street (Route 2A) was built in 1838 to serve the First Congregational and Baptist congregations. There was also sufficient land behind for a cemetery. (Courtesy of Joyce Sweeney.)

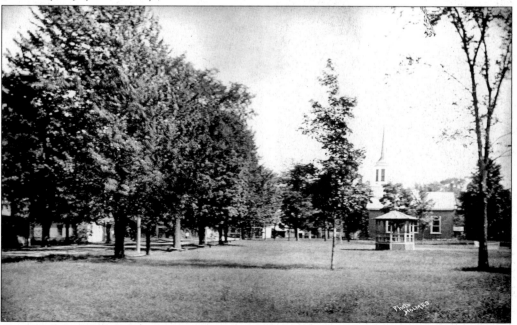

The bandstand (in the foreground) for years heard the melodious sounds of the Colchester Town Band. The bandstand was restored and relocated to the parade grounds at Fort Ethan Allen, but not so the band. While the town has a Colchester Community Chorus of which it is most proud, a band today is woefully missed. (Courtesy of Joyce Sweeney.)

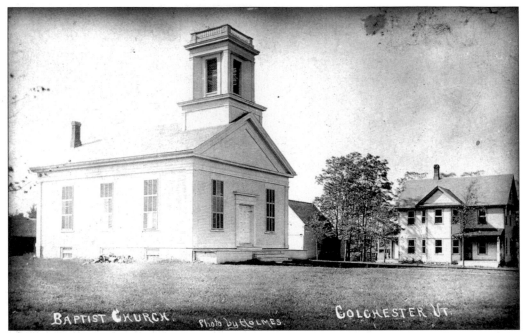

Breaking away from the agreement held with the Congregational church and anxious to establish their own church, the congregation of the Baptist church erected their own building in 1861. Located just west of the other church on Main Street, it was to be a 36- by 50-foot double-aisled meetinghouse. Additional land was acquired behind this building that further expanded the cemetery. (Courtesy of Joyce Sweeney.)

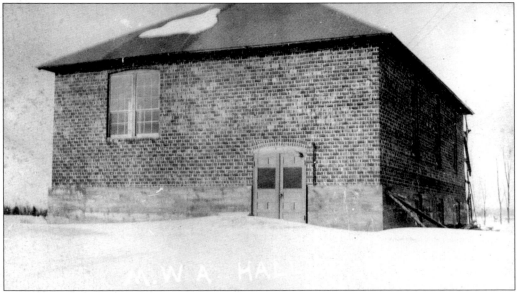

The Methodist congregation purchased a lot from Ira Robinson in 1860 and built a church building that was similar in style to the Baptist church. It later became the Ethan Allen Camp No. 12466 of the Modern Woodmen of America Hall in 1909. The hall was demolished in 1980 to make way for the Colchester Center Volunteer Fire Company building. (Courtesy of Joyce Sweeney.)

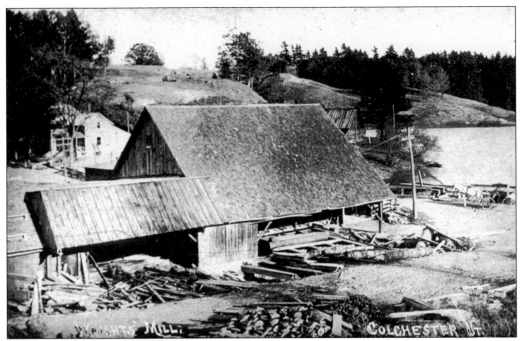

The original mill that burned in 1870 was built by the brothers Hezekiah and William Hine before 1802. Mill Pond Road (formerly called Old Country Road) derives its name from this mill. (Courtesy of Gloria and Charles Scribner.)

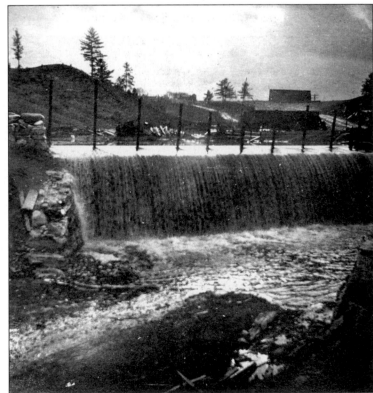

The dam was used by the Hine Mill that later became the Raleigh Wright Mill. Lumbering was a lucrative business in the early days and made the Hine and Munson families wealthy and influential. (Courtesy of Joyce Sweeney.)

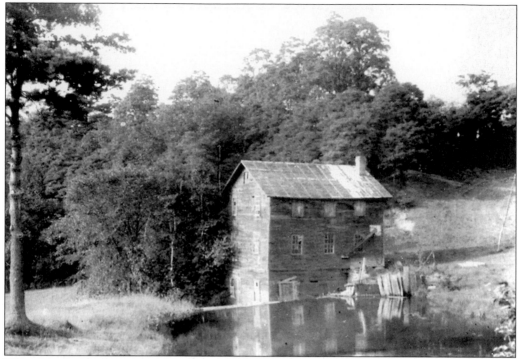

This photograph shows the sawmill on Indian Brook at the intersection of the County Road (Route 2A) and West Road (Route 7) across from the Munson homestead. It was originally built by William Munson in the early 1800s. The old mill apparently "fell down" c. 1914.

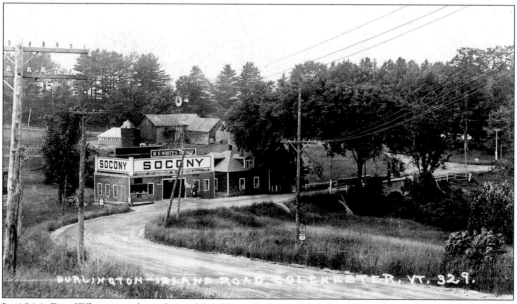

In 1914, Ray White purchased an old cider mill along the Indian Brook on the west side of the village and, in 1917, started one of the first garages in town. He later built his own home next door to the garage. The Burlington-Island Road (Route 329) was later altered and is today called Lakeshore Drive East. (Courtesy of Joyce Sweeney.)

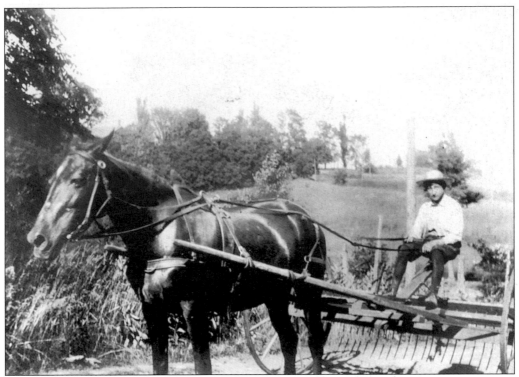

William Munson and old Doll, his horse, ride below the house on Bay Road (now Lakeshore Drive East) in the early 1900s. (Courtesy of Becky Munson.)

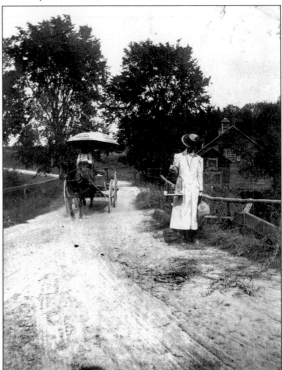

There was a myth that an "old maid" always carried a bird in a bird cage. A young lady poses c. 1903 just for fun as one such "old maid." Shown behind her is the cheese factory that Ray White bought and turned into a garage by the bridge and now Munson Road. (Courtesy of Becky Munson.)

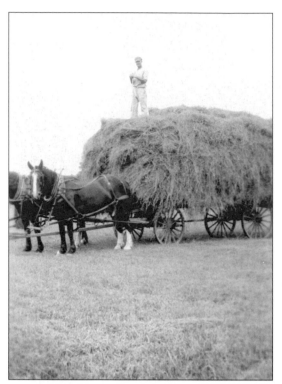

Other occupations in the early 1900s included farming. Here we see Henry Severance on top of his hay wagon on his farm, located on the corner of Severance Road and Roosevelt Highway. (Courtesy of Joyce Sweeney.)

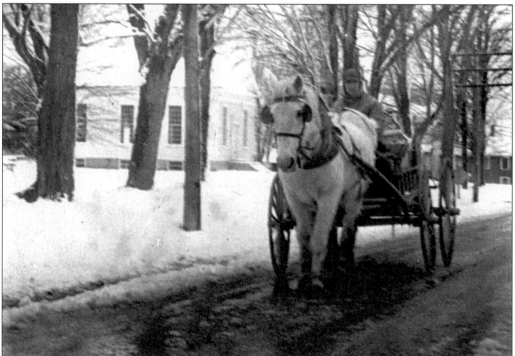

Max Wolcott made this milk delivery run from the creamery on Main Street to homes in town. His horse, Bill, led the way until the creamery closed in 1955. This photograph was taken in the early 1940s. (Courtesy of Eben Wolcott.)

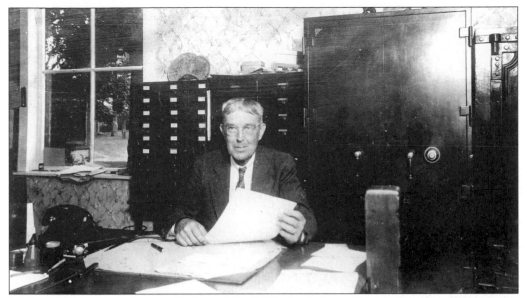

J. Murray Wright was the grandfather of Clark Wright, father of George Lawrence Wright, and the town's clerk from 1922 to 1949. He is shown here in the old town clerk's office at the northwest corner of East Road and Mill Pond Road intersection on Route 2A in the 1940s. (Courtesy of the Colchester Historical Society and Becky Munson.)

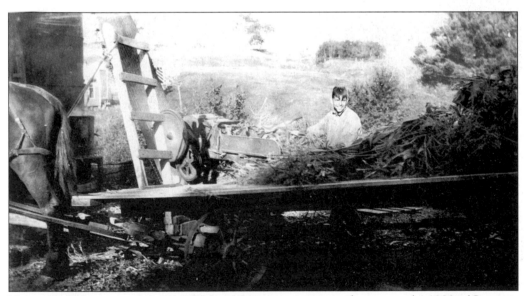

Using an old "cutter and carrier," Walter Munson is cutting in the corn c. the 1920s. (Courtesy of Thelma Wright.)

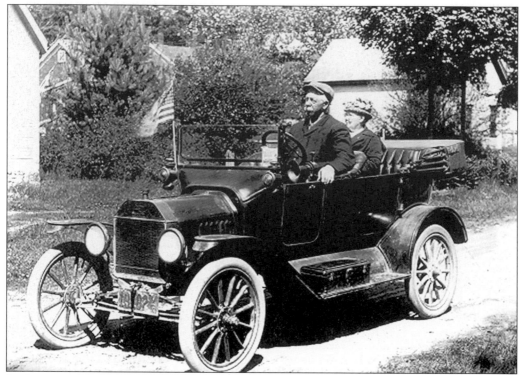

Joe Farnsworth is identified on this early-1900s photograph as the "inventor of the telephone." He did, in fact, make telephones but could not sell them until 1890 because the Bell Company patent did not expire until then. He did, however, start the Central Telephone Company, which supplied Essex, Colchester, and Milton. He sold the Milton line in 1920, and Colchester Center was added to other New England telephone lines with a "central" at Essex Junction.

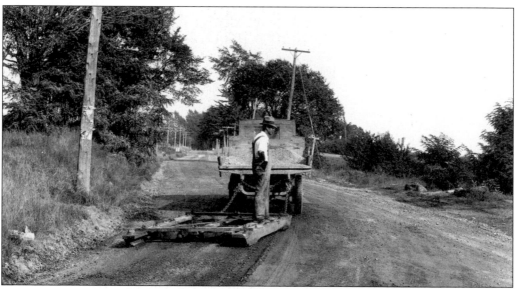

George Henry Pratt, road commissioner from 1922 to 1924 and again from 1926 to 1930, is shown here grading East Road at its junction with Depot Road. (Courtesy of Jody Pratt.)

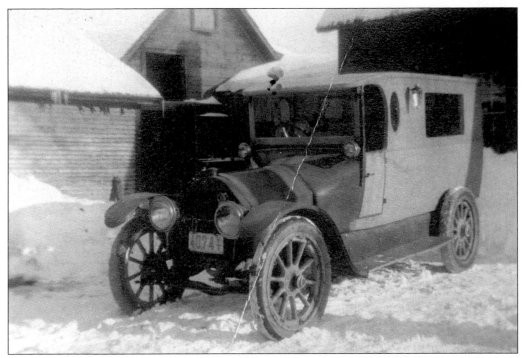

This car's body was made by H.S. White to be an ambulance. It was sold to Corbin and Palmer in the early 1900s. (Courtesy of Joyce Sweeney.)

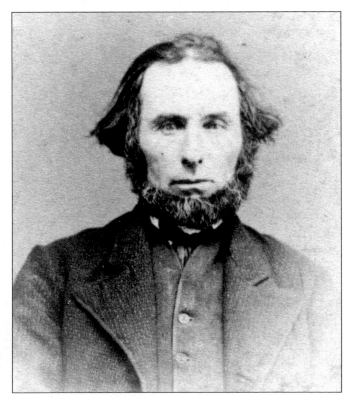

Photographs of members of some of Colchester's earliest families follow. Israel Hine, father of Adin and Libby Hine and husband to Adaline Farrand Hine, is shown here c. the late 1800s. (Courtesy of the Colchester Historical Society and the Clara Mayo Harvey family.)

Capt. Henry T. Mayo (born in 1802) commanded a packet boat on Lake Champlain from 1833 until 1887. He fathered nine children, had a farm in town, and helped build a one-room school. (Courtesy of the Colchester Historical Society and the Clara Mayo Harvey family.)

Walter and Harriet Button are shown with their son Chester. Walter was the Colchester Lighthouse keeper from 1882 to 1888, from 1890 to 1892, and from 1892 to 1901. They were on the lighthouse one cold night in January when Harriet was to deliver a baby. A prearranged signal was received by Burlington's Dr. Hawley that brought him to the shores of the not yet completely frozen lake. Despite the flimsy ice, he chanced walking on it only to hear a loud cracking noise; he and Button's assistant floated out to sea. They jumped from one piece of ice to the other, finally making it to safety on the shores of South Hero. Harriet gave birth in the lighthouse to Myrtle Edna Button, their fifth child. Chester Button became a lighthouse keeper in 1901–1908. (Courtesy of Eugene Button.)

Lt. Col. William D. Munson (1833–1903)
served as town clerk and in the Civil War.
He was a Norwich College graduate and
married H. Juliet Henderson Munson.

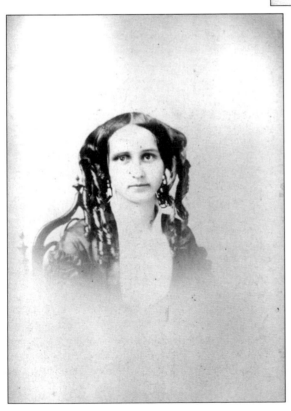

Julia Munson is shown in this
mid-1800s view.

Shown here are the children of William D. and Julia Munson—William H. and Mildred May Munson. (Courtesy of Becky Munson.)

William Henry M. Munson (1857–1929), son of William D., served on the school board and in World War I. With Mertie Thompson Munson, William had two sons and two daughters—William, Walter, Millie, and Marion. (Courtesy of Becky Munson.)

Pictured here is William Munson, son of William Henry and Mertie Thompson and brother to Walter, Millie, and Marion. (Courtesy of Becky Munson.)

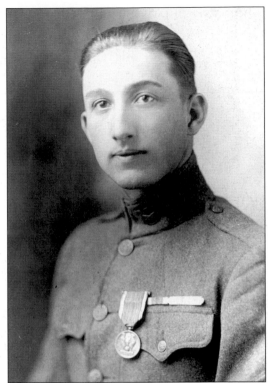

Walter Munson (1903–2000) was the last Munson in Colchester, and with no children of his own, the Munson legacy ended here. His widow, Becky Munson, a genealogist, has researched and chronicled the family's history and continues to live in the family home on Munson Road. (Courtesy of Becky Munson.)

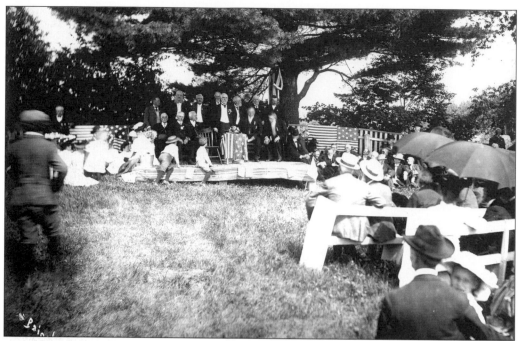

Here we see the dedication of Col. William Day Munson's monument *c*. 1905, in the Munson Cemetery. The cemetery is the final resting place for all of the Colchester Munsons, with the most recent addition being Walter W. Munson, who passed away in 2000 at the age of 98. It is located on a hill behind the Munson farmhouse off Route 7. (Courtesy of Becky Munson.)

Shown *c*. 1908 are Bill (left), Walter (center), and Millie Munson. (Courtesy of Becky Munson.)

This late-1800s photograph shows William Henry Munson with his wife, Mertie. (Courtesy of Becky Munson.)

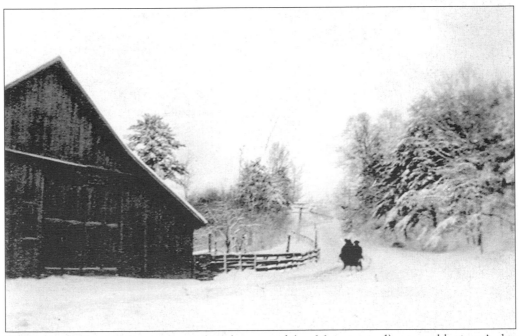

William and Mertie Munson leave their homestead (on Munson road) on a cold winter's day in Colchester and head for Burlington. (Courtesy of Becky Munson.)

William and Ginny Bombard, pictured in the late 1800s, were the parents of Adelaide Bombard Button, who married Lloyd Button. Adelaide had two sisters, Janice and Juanita. Juanita married a Severance, and their children, Joyce Sweeney and Malcolm Severance, still live in Colchester. William Bombard served as a school board member for close to 20 years. (Courtesy of Eugene Button.)

Pictured c. the 1920s are, from left to right, sisters Rachel Carey, Ruth Carey Button, and Mae Carey by the Button homestead on Route 7. (Courtesy of Eugene Button.)

Neal Carpenter, in his World War I army uniform, rows on Colchester Pond in the early 1900s. Eighty-seven men from Colchester served during that war. Only one, Clyde Parker, was killed in action, and Spencer Pfeegor died of disease while stationed in Florida. (Courtesy of Miriam Keating.)

Ruth E. Carpenter plays on the lawn of her house, at Middle Road and Main Street, c. 1930. Note the old town hall and the school in the background. (Courtesy of Miriam Keating.)

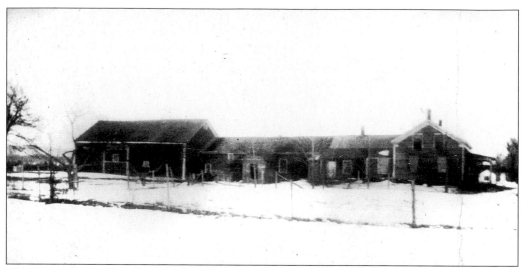

The Benjamin and Ida (Logsden) Carpenter house sits at the corner of Middle Road and Main Street. It was sold to their son Neal, who resides there still with his wife, Bernice. The house was constructed in 1841 by Henry Severance. A fire in the barn in 1930 killed two workhorses and numerous chickens and destroyed a car. According to daughter Miriam Carpenter Keating, who was four years old at the time, "people going by stopped and emptied the house of furniture, clothing, and dishes. Nothing was lost or stolen when everything was put on the lawn temporarily." (Courtesy of Miriam Keating.)

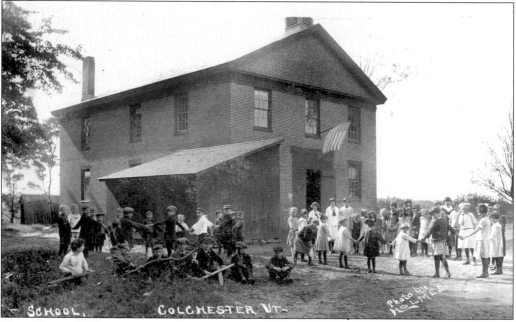

The old town hall on Main Street (Route 2A), across from the old fire station, also served as a schoolhouse in the early 1900s and was referred to as District No. 1 School (or simply the Academy). In 1850, its male teachers were paid $65 for 14 weeks of work, its female teachers $24 for 16 weeks. Wood cost $12.50, so to educate 77 students that year, $99.50 was spent. The school tax for the year 1865–1866 was 40¢ in that district. (Courtesy of the Colchester Historical Society.)

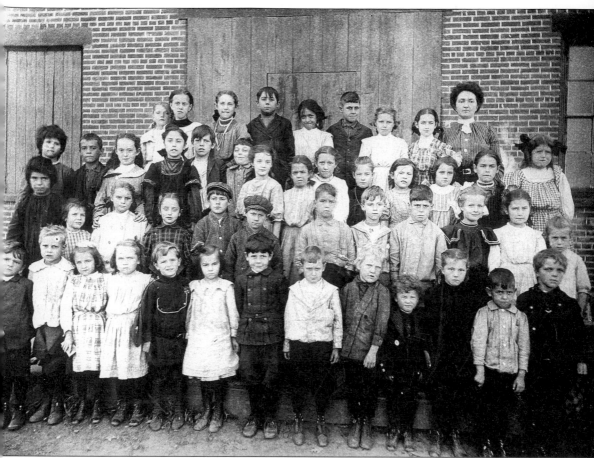

The Town Meeting Hall School is pictured c. 1909. From left to right are the following: (first row) Elmore Rivers, Vernon Newton, Madeline Plunket, Leota Carey, Otney Plumket, Eva Greenough, Merle Carpenter, Clarence Davison, Edward Anderson, Curly Worthen, Carrie Worthen, Walter Munson, and John Rivers; (second row) Emma Pecor, Adelaide Bombard, Dorene Wheeler, Clara Cadorette, unidentified, unidentified, Laurence Wright, Hudson ?, Marcus Washburn, Katherine Sibley, Frances Sweeney, and Elizabeth Hulbard; (third row) ? Pecor, Elmer Greenough, Nancy Davison, ? Cadorette, ? Rivers, Clyde Carpenter, Eva and Laura Greenough, Marion Florence, Roxie Hulbard, Frieda Huntress, Artell Rice, Anna Gardner, and Nina Anderson; (fourth row) Alice Worthen, Nettie Hulbard, Bessie Gardner, Clarence Parrott, Hazel Huntress, Frank Washburn, Doris Wright, Enice Morgan, Myrtle Button. (Courtesy of Eugene Button.)

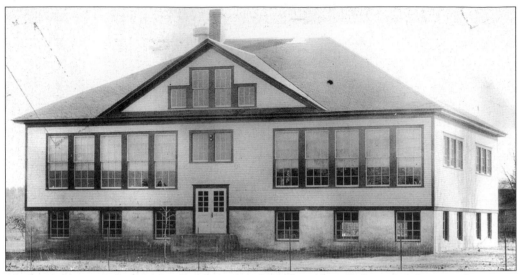

The Union Upper School, also called the White School and later dedicated as the Leonel Paquette School, is now a commercial establishment. (Courtesy of the Colchester Historical Society.)

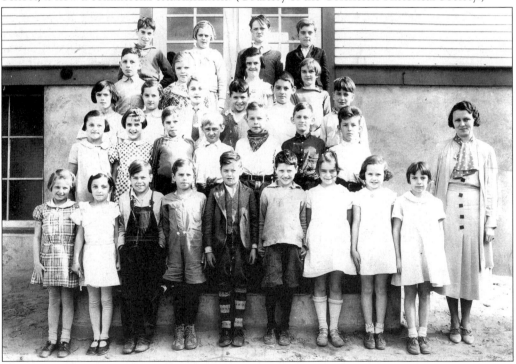

The third and fourth grades of the Union Upper School pose c. 1936. From left to right are the following: (first row) ? Stygles, Jeanette St. Gelais, Johnny Manning, Pete Lavely, Bobby Parizo, Robert Sweet, Patty Tatro, Givenny Baker, and Lida Wolcott; (second row) Miriam Carpenter, Gertrude Washburn, unidentified, unidentified, Walter Cleveland, Kenneth LaBlanc, and Cleon Richards; (third row) unidentified, Eleanor Glidden, Robert St. Gelais, Irwin Sweet, Larry laBlanc, and Jean Paul Varin; (fourth row) Donald LaBlanc, Thelma Wright, unidentified, and Cecil Varin; (fifth row) ? McKenna, Dorothy Parizo, ? Worthington, and Johnny Rivers. (Courtesy of Thelma Wright.)

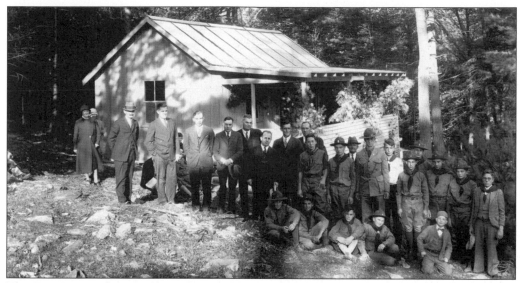

This Boy Scout cabin was located on Colchester Pond. Pictured here are the following: (front row, seated) unidentified, Warren Collins, Guy Richards, Hoppy Stanley, and Carroll Stygles; (back row, standing) Hattie Somerville, unidentified, Hank White, unidentified, Roger Curtis, A. Ritchie Law, Ray Collins Sr. (who pitched for the Boston Red Sox), Charles King, Neal Carpenter, unidentified, unidentified, Noah Thompson, Howard Stanley Sr., "Doc" Clayton Cilley, Doug Wright, Maurice Thayer, Larry Pitts, Roland Thompson, Billy Stetson, and Joey Purms. (Courtesy of the Winooski Valley Park District.)

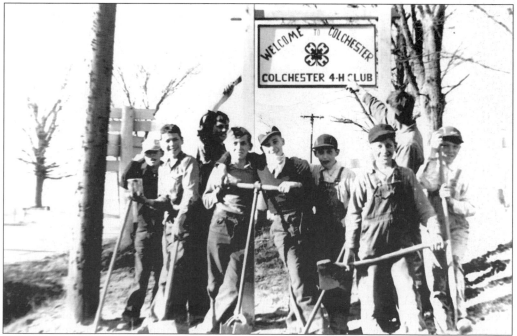

In addition to an active Boy Scout program, the Colchester 4-H Club also offered young boys activities to serve their community. Some of the youngsters involved with erecting a new sign in town in 1938 are Warren Sweeney (fourth from the left), Malcolm Severance (fifth from the left), and the Carpenter twins (sixth and ninth from the left). (Courtesy of Joyce Sweeney.)

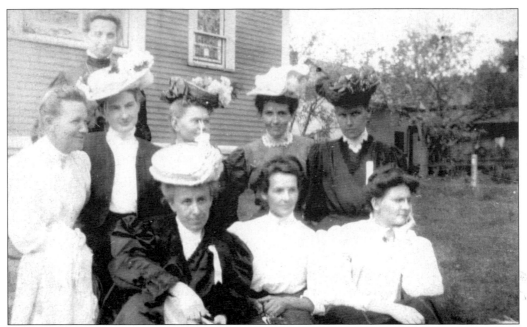

For the ladies—the grown-up ladies, that is—there was the Colchester King's Daughters of the Congregational Church. This energetic group performed charitable and service functions as well as being a social and devotional group. They started the public library, which in 1900 had 47 books to loan from Hattie Hill's rooms over the store on the northeast corner of Route 2A and East Road. They paid $1.50 a month for the space and turned it over to the town in 1911. They also supported the Colchester town band by paying the rent on their rehearsal space. Shown here in the early 1900s are, from left to right, the following: (front row) Minnie Munson, Lena Thayer, and unidentified; (middle row) Sabra Bates, Anna Morrow, Ethel Hulburd, Gertrude Carey, and Alma Wright; (back row) Mae Thompson. (Courtesy of Martha Scanlon Sanford.)

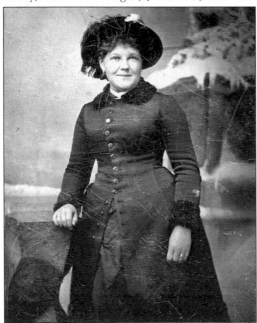

Sabra Bates is shown here c. the late 1800s. (Courtesy of Martha Scanlon Sanford.)

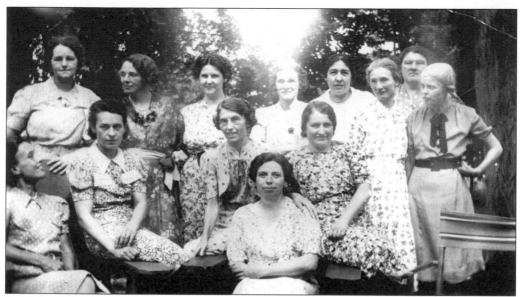

In this early-1940s view, the King's Daughters are shown still working to enhance the community, but with a different set of members. From left to right are the following: (front row, sitting) Gladys Nichols, unidentified, Frances Sweeney, Florence Wolcott, and unidentified; (back row, standing) unidentified, unidentified, Marge Washburn, Ada Monta, unidentified, Aunt Nora (part of the Wolcott family), unidentified, and unidentified. (Courtesy of the Wolcott-Cloe family.)

Etta and Herbert Burnham are pictured c. the late 1900s. Etta was born in Colchester in 1863 and married Herbert (born in 1859) here in 1883. Childless, the couple lived during his working years in Massachusetts, returning to retire in 1926. She, too, was a member of the King's Daughters and was chair of the library trustees. He died in 1932, she in 1939, leaving virtually their entire estate to the building, furnishing, and maintenance of a library. The library was dedicated to the Burnhams on August 14, 1942. (Courtesy of Pat Carty and Sue Parsons Bouchard.)

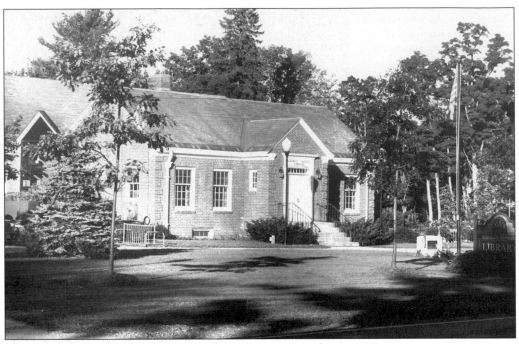

The Burnham Memorial Library is shown as it appears today.

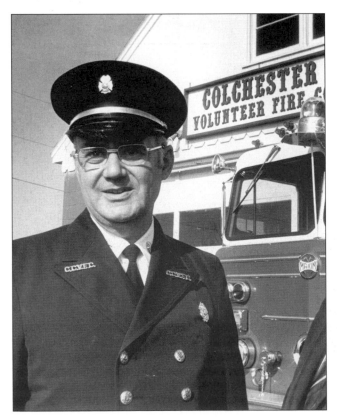

The Colchester Center Volunteer Fire Company was founded in 1951 by Ray White, Neal Carpenter Sr., Henry Sweeney, Jack Keyser, Homer Leggert, Marcus Washburn, Grant Kennedy, Cliff Kimble and Roy Penoyer. Roy Penoyer was its first chief, and Ed Stowe (shown here) followed with 30 years as chief until 1985, still serving today as its deputy chief with more than 50 years of volunteer service. The department offers Colchester Village residents an ISO 3 rating, the only volunteer fire company in the state to carry that insurance premium rating. (Courtesy of Ed Stowe.)

One of the bigger fires in recent years was the Ray Collins barn on Roosevelt Highway, Routes 2 and 7. The barn was completely destroyed. The Malletts Bay Fire Department and St. Michael's Fire and Rescue (under the auspices of CCVFC) are all volunteer emergency units. Colchester Rescue has full-time employees and a full roster of volunteers. (Courtesy of Ed Stowe.)

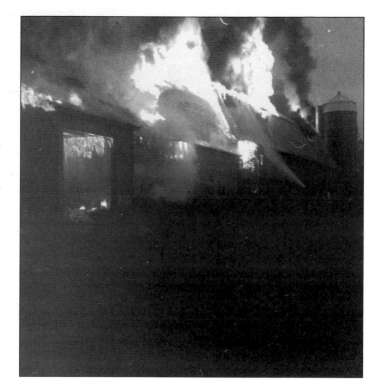

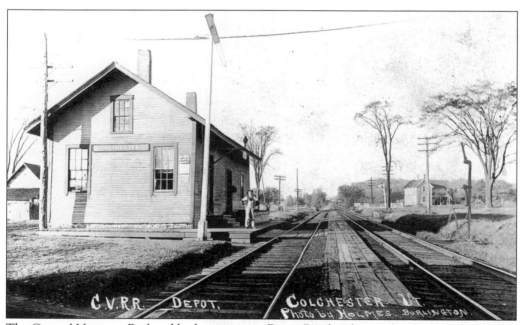

The Central Vermont Railroad had a station on Depot Road with a station agent and telegraph operator on duty for several hours a day. Trains loaded with freight came and went to Montreal, Canada. The Central Vermont Railroad closed its passenger station on Depot Road in the early 1940s, but freight trains continue to run today. (Courtesy of Joyce Sweeney.)

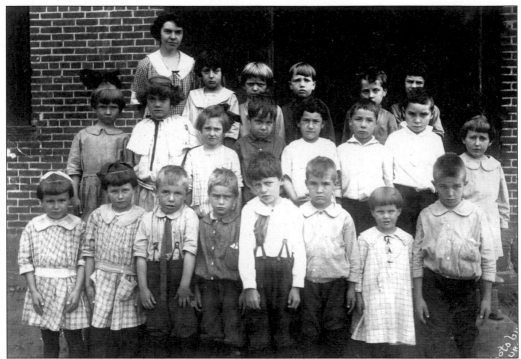

Here we see the Town Meeting Hall School first- and second-grade class of 1924–1925. From left to right are the following: (front row) the Quinlan twins, Douglas Wright, unidentified, Ronald Sweeney, Lawrence Richards, Thelma Wright, and Harold Richards; (middle row) Eunice Wheeloch, Lucille Stetson, Eleanor Stygles, Grant Bettis, unidentified, Lawrence Bergeron, Harold Bergeron, and Florence Boseley; (back row) Mabel Guyette, Sylvester Thompson, Alwyn Button, Hudson Carey, and Janet Collins. The teacher was Adelaide Bombard (later Button). (Courtesy of Thelma and Doug Wright.)

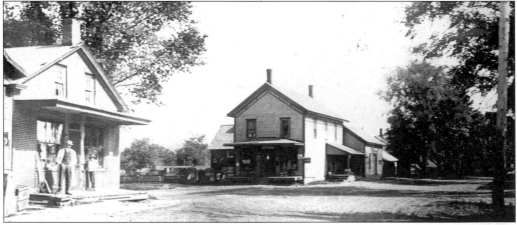

This parting photograph shows what was the center of Colchester in the early 1900s. The building in the center was the general store and post office. It burned in September 1922. Eben Wolcott's father was born in 1891 on the second story, and his grandfather and great-grandfather owned and ran the store. It is located on the corner of East Road and Route 2A (Main Street) and later became Ploof's Market (now closed, but still rented commercially). (Courtesy of Alta White and Joyce Sweeney.)

Two

CLAY POINT

The rugged beauty of this area of town includes the Clay Point Road Caves, a natural area inventoried by the Vermont Agency of Natural Resources. There are three miles of frontage on the Lamoille River that are forested and inaccessible and sustain a productive wildlife habitat. Approximately four and a half square miles in size, the Clay Point area of town may be the least populated with approximately 1,000 residents. Its name is derived from the extraordinarily fine clays that constitute its soils. It is located in the northwest corner of town extending from Chimney Corners on Route 7 to the Milton border. In 1906, there were 29 students from this area, and today the Mountain Transit school bus driver for the Clay Point area reports approximately 27 students. Many of the roads are named after early residents such as Mayo, Raymond, and Jasper. Braelock Road is Scottish for "hill and lake," an apt description of this pristine and beautiful natural area of town.

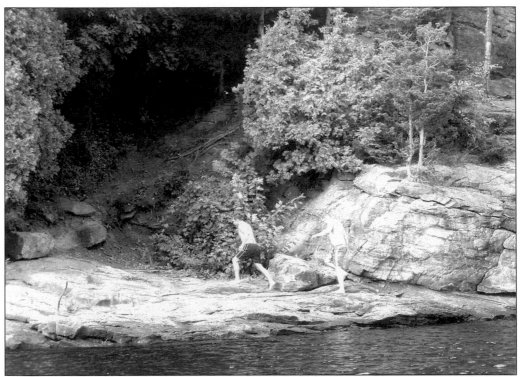

This view shows swimmers on the shore of Niquette Bay. Niquette State Park, a 290-acre parcel on the northern shore of Malletts Bay, has been a state park for 28 years. It has 4,720 feet of sandy beach and a rocky frontage on Calm Cove in Niquette Bay. One prehistoric site has been located at the park dating back to the late Archaic period (up to 6,000 years ago). Logging and farming were prior uses, with jasper quarrying activity evident in the northern end of the park. Rare flora, such as *Quercus muhlenbergii,* and a rare species of slave ant, *Leptothorax duloticus Wesson,* have been noted in the park. (Courtesy of Inge Schaefer.)

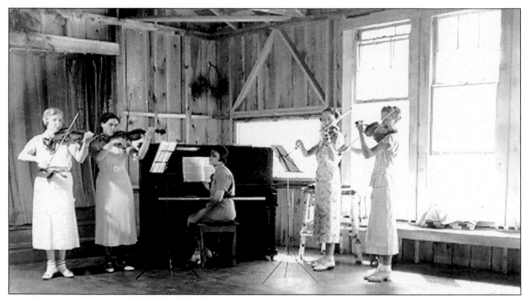

Camp Kiniya, a 100-acre camp for girls ages 7 to 17, dates back to 1920. Helen Van Buren, a Burlington piano teacher, purchased the property and started a summer camp with an emphasis on music and outdoor life. Early campers are shown here practicing their instruments. (Courtesy of Marilyn and Jack Williams.)

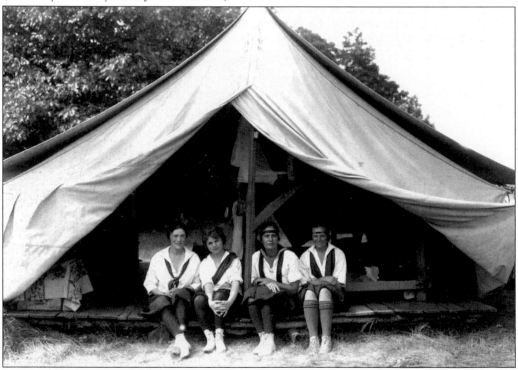

Marilyn and Jack Williams bought the camp in 1951, and it remains in their hands today. Marilyn describes the camp as "old-fashioned fun within a wholesome community" where sports of all kinds are offered, along with dance and drama. Note the uniforms worn by the campers shown here relaxing in their tent. (Courtesy of Marilyn and Jack Williams.)

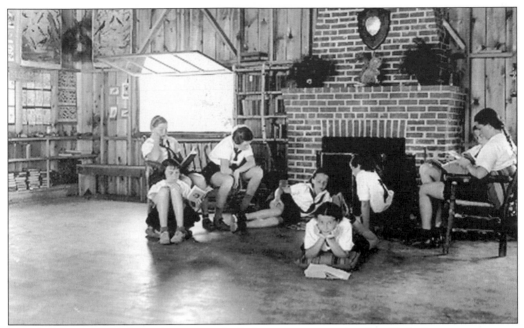

The tradition of evening gatherings in the lodge continues to this day. Today's campers cannot bring radios, and headphones are allowed only at night. There is no television. The international influence of campers and counselors from such exotic places as Hong Kong, Iran, and Australia adds to the diversity of activities available at this Clay Point landmark. (Courtesy of Marilyn and Jack Williams.)

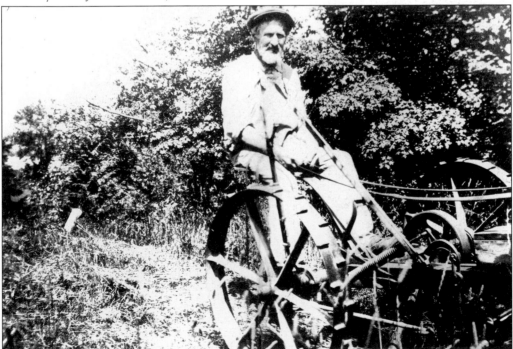

One early resident of the area was Thelma Wright's grandfather, Benjamin Monty, shown here on his horse-drawn mowing machine. (Courtesy of Thelma Wright.)

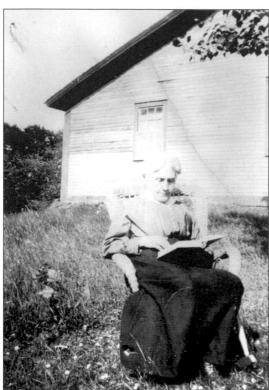

Almira Monty, Benjamin's wife, shown here in the late 1800s reading by the farmhouse, referred to the Clay Point area as the "Champlain" part of town. (Courtesy of Thelma Wright.)

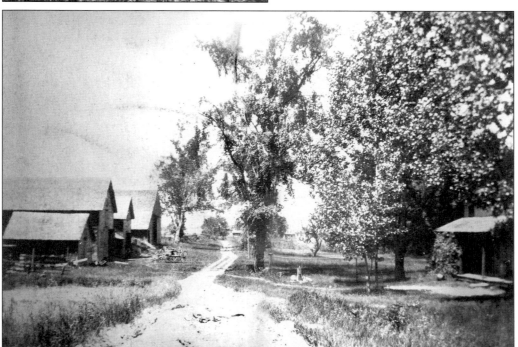

Also shown is their farm on Route 2 (the property sloped down into the Lamoille River), dating from the early 1800s. The name Monty later became Monta, probably as a result of a handwritten clerical recording error. (Courtesy of Thelma Wright.)

Here we see the Monta farm on Route 7, the road to the Champlain Islands. (Courtesy of Thelma Wright.)

Ben Monty, shown c. 1850, would row his boat up the river to West Milton to shop. (Courtesy of Thelma Wright.)

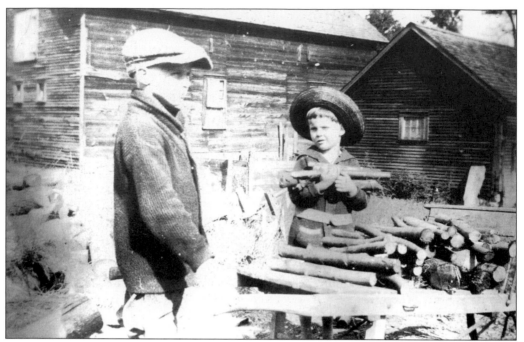

Robert Monty and Thelma Monty (who married Doug Wright) were the grandchildren of Benjamin and Almira and are shown here stacking wood at the Champlain farm. (Courtesy of Thelma Monta Wright.)

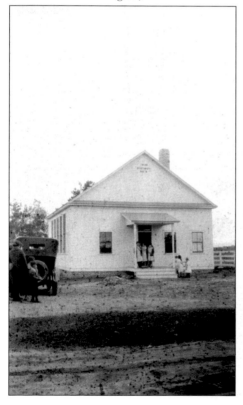

Awarded a state prize as a "superior school," the Champlain District School was located on old Route 2, the road to the islands. This photograph dates from the early 1930s. (Courtesy of Thelma Wright.)

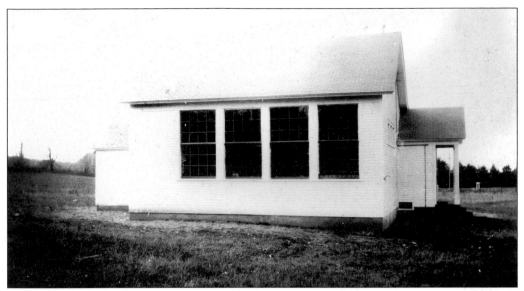

This Champlain School photograph was taken in 1934. The school is no longer in use. (Courtesy of the Colchester Historical Society.)

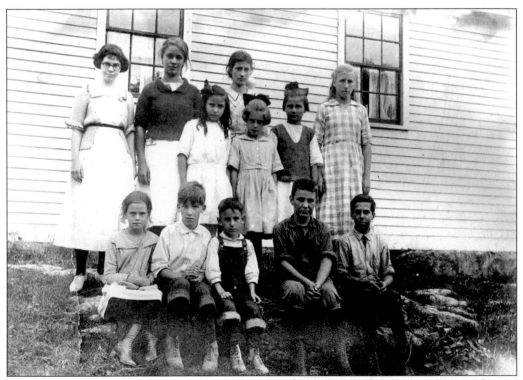

This is the Champlain School class of 1921. Adelaide Bombard (Button) is on the left in the back row. (Courtesy of the Colchester Historical Society.)

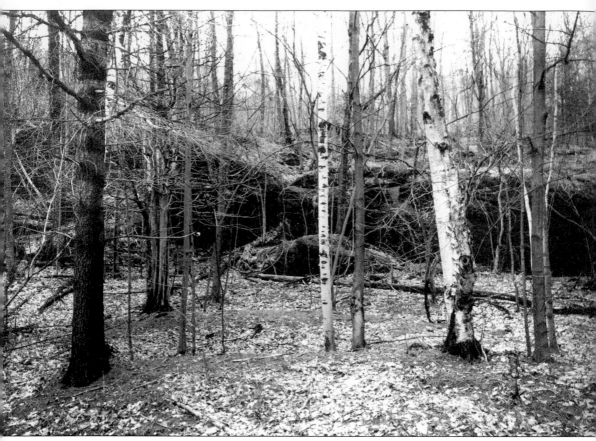

This view captures the rugged beauty of the Clay Point area. (Courtesy of Inge Schaefer.)

Three

MALLETTS BAY

The bay by any other name may be Mallet. Often a bone of contention, the name Malletts Bay may have originally used the French pronunciation "Ma-lay" after Capt. Stephen Mallet. (Or was his name Pierre Mallett or even Jean-Pierre Mallett?) Little is known of this reportedly high-seas swashbuckler who built a home and kept a tavern for spies and smugglers, fearing neither principalities nor powers. Vermont historian Ralph Nading Hill writes, "Captain Mallett was apparently a man of considerable independence of spirit; he feared no one and acknowledged allegiance neither to the English King nor to the American colonies." Research on Mallett done by Albert Gravel, Winooski's mayor in 1939, had Mallett "absconding from France with the regimental funds from Napoleon's Army." His descendants deny the story. It is said that Ira Allen came upon him living on Malletts Head (the area at the end of Marble Island Road). Allen wrote, "His settlement had the appearance of great antiquity." Despite an effort in the 1860s to change the bay's name to Winooski Bay, Malletts Bay (with two *T*s) has stuck. Captain Mallett's free spirit suits this largest bay in Lake Champlain where winds and waves can vary considerably from one end to the other.

For this book, we will consider the Malletts Bay area to extend from the Heineberg Bridge that connects to Burlington, the Young Street area that borders Winooski, up to the interstate by Lone Pine Campsites. There are approximately 7,500 residents within this area.

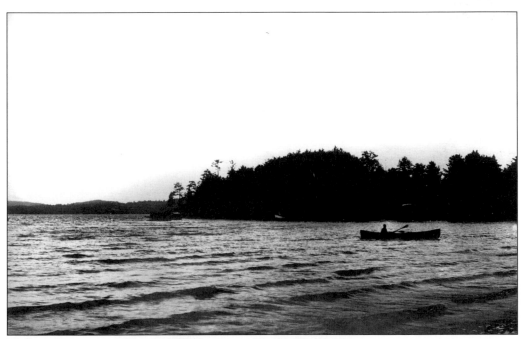

Malletts Bay is pictured *c.* 1915. (Courtesy of Becky Munson.)

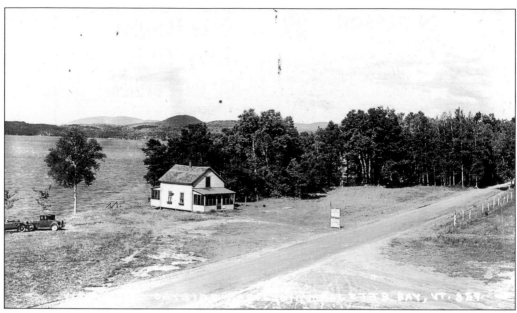

"A Hot Time in the Old Town Tonight" is what Clarey's Bayside Pavilion on a Saturday night meant to thousands of locals and tourists from the early 1920s through 1963. George Clarey (born in 1885) saw a potential for 25 lakefront acres located in Colchester. A cottage (shown here) was already on the lakeshore side. (Courtesy of Ruth Morgan.)

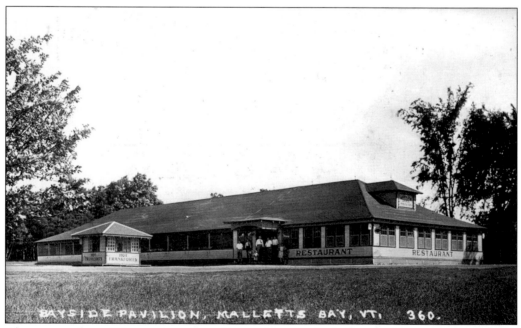

Clarey wanted to offer young people a place to dance, so he built a spacious one-story building directly across the street that he called the Bayside Pavilion. Opening in 1925, it was an immediate hit. (Courtesy of Ruth Morgan.)

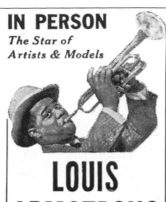
The Big Band era had begun, and such stars as Duke Ellington, Cab Calloway, and (in 1935) Ozzie Nelson's Band, featuring his vocalist Harriet Hilliard, arrived in Colchester to the delight of huge crowds. Still later, on the nights Benny Goodman, Glenn Miller, and Tommy Dorsey played, as many as 5,000 crowded the expanded dance hall. (Courtesy of Ruth Morgan.)

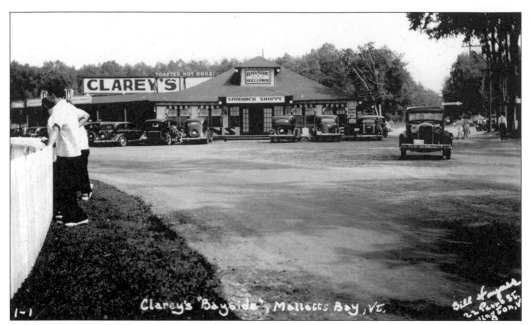

Cars became more popular in the 1930s, allowing more and more tourists to travel to Colchester. (Courtesy of Ruth Morgan.)

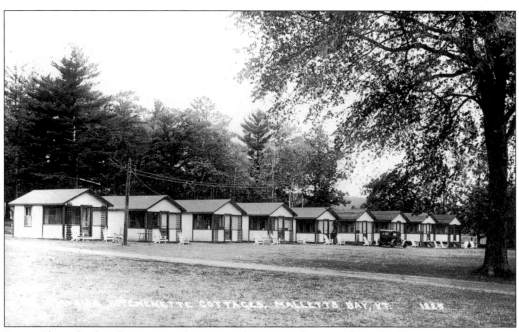

Soon, Clarey built cabins across the street where now the Bayside Park offers tennis courts and a pavilion. (Courtesy of Ruth Morgan.)

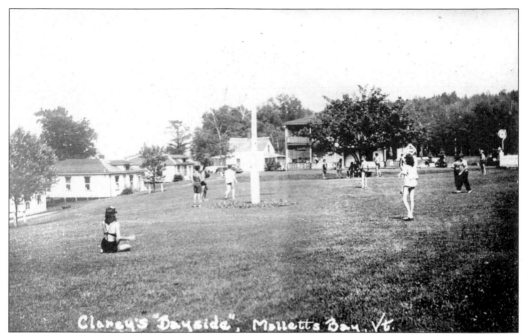

In the 1940s and 1950s, the Bayside Pavilion offered roller-skating during the week, a juke box, and dining. Swimming, ball games, rowboats, bicycles to rent, horseshoes, basketball, table tennis, and even a caged monkey named Chico were some of the activities available at this jewel popularly called Clarey's on Malletts Bay. On the lakeside, Clarey built additional cabins and a two-story lodge. (Courtesy of Ruth Morgan.)

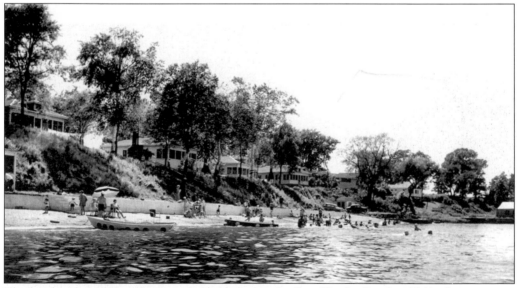

The last band to play at the Bayside Pavilion was the Ray Charles Band in 1963, the same year George Clarey died. In 1964, the pavilion mysteriously burned to the ground. The property was purchased by the town in 1968 for $150,000, most of which was paid for by Bureau of Outdoor Recreation funds, with the town only paying $37,500. It was quite a bargain. The cabins were auctioned off, and for many years, only the fireplace chimney stood as a reminder of the magnificent Clarey's Bayside Resort. (Courtesy of Ruth Morgan.)

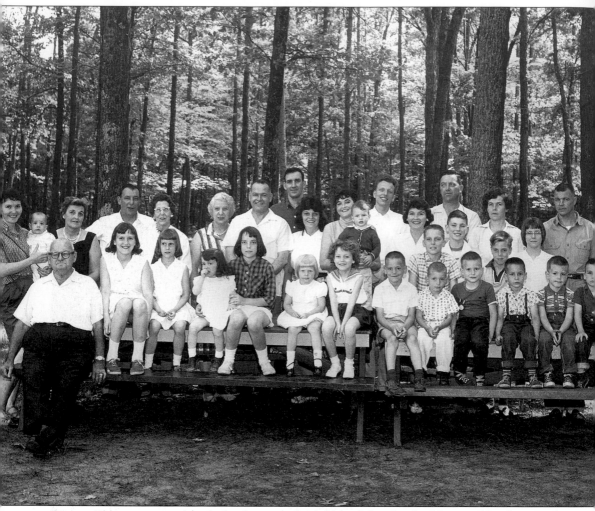

George Clarey sits on a bench (in front on the left) with his family. His granddaughter Ruth Clarey-Dunn Morgan still lives on Lakeshore Drive and recalls that her grandfather "was frequently fined for possessing gambling devices, generally pinball and other machines referred to as 'one-armed bandits.' " He was even shot once by burglars. His daughter (Ruth's mother) Dorothy Dunn, who still lives in Vermont, was in charge of the staff, while her sister took care of the office and their brother Jimmy handled the Bayside Pavilion. Ruth Morgan is the second from the right in the last row, next to her husband, Charlie, on the end. (Courtesy of Ruth Morgan.)

These bathing beauties—Frances White Sweeney (left) and Ruthie Clark—could be found on the shores of Malletts Bay c. 1915. (Courtesy of Joyce Sweeney.)

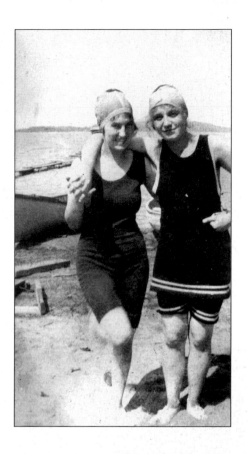

Another popular summer hangout (particularly for locals) was Nourse's, a hot dog stand at the bend by Goodsell Point on Lakeshore Drive. (Courtesy of Joyce Sweeney.)

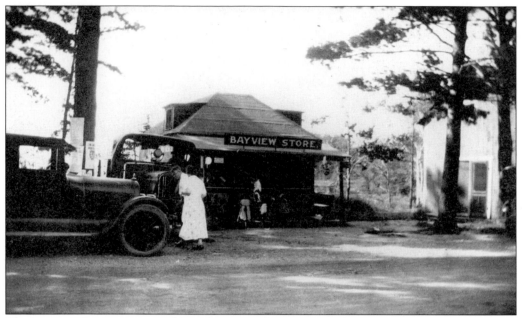

The Bayview Store was opened by Johnny Yandow c. 1930. The location was at the corner of Goodsell Point and what is now Lakeshore Drive East. (Courtesy of Theresa Levebvre.)

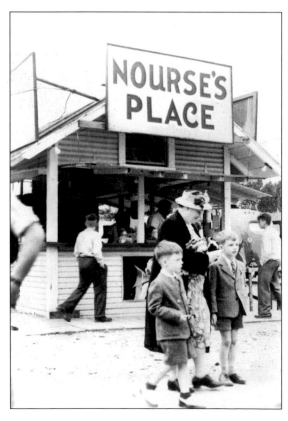

Locals Ed Conant (left) and his brother Sam Conant, with their grandmother Nina Conant, are shown at Nourse's c. 1949. (Courtesy of Joan and Ed Conant.)

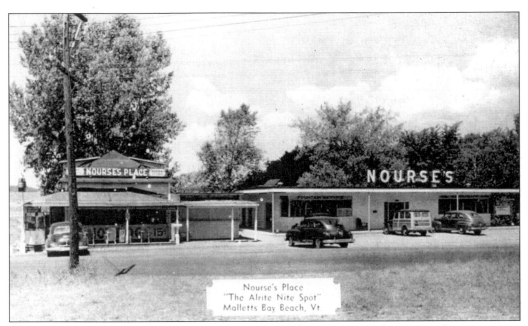

Jerry Sweeney recalled working at Nourse's in the early 1940s: "Hot dogs were 15 cents a piece or two for 25 cents. I worked six days a week from 12 noon until 11 or 12 p.m. and was paid $10 a week, and was lucky to have the job." (Courtesy of Theresa Lefebvre.)

In 1957, Nourse opened a modern restaurant. After several different owners, the site is now occupied by a two-family condominium. (Courtesy of Joan and Ed Conant.)

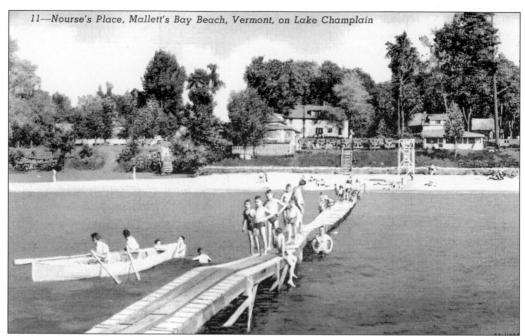

The beach attracted swimmers from neighboring camps and the many cabin rentals dotting the shore. Cavalry soldiers from Fort Ethan Allen cleaned the beach with rakes and shovels and took with them whatever they pulled in (clams, weeds, debris). (Courtesy of Joyce Sweeney.)

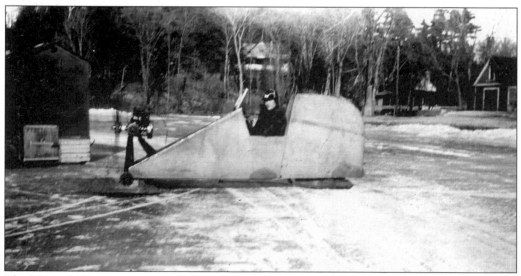

The Nourse's Corner area was used year round by locals who, in the winter, tested what might have been an early iceboat-snowmobile built and driven by Ray White. (Courtesy of Alta White and Joyce Sweeney.)

58

Iceboating has long been popular on Lake Champlain and particularly on Malletts Bay. (Courtesy of Alta White and Joyce Sweeney.)

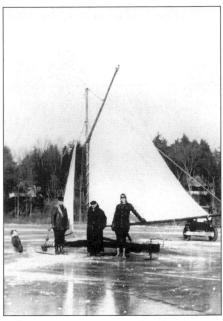

Cutting and selling ice to residents was an important job. After the ice was cut, it was kept cold throughout the next summer in backyard icehouses packed with sawdust that came from the gristmill. (Courtesy of Joyce Sweeney.)

Anna White stood on this natural stone dock on Goodsell Point waving a lantern so that Ray White, on his boat the *Frances Anna*, could come in to load and unload passengers in the early 1900s. (Courtesy of Joyce Sweeney and Alta White.)

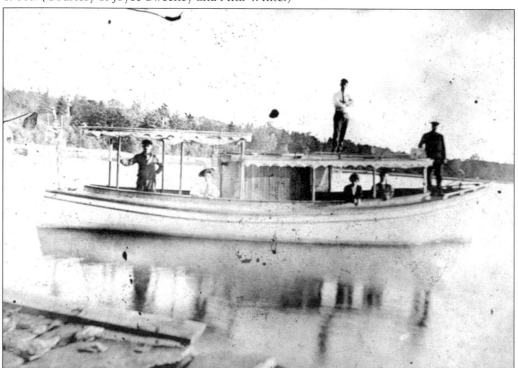

The *Frances Anna*, built in 1909, is shown without its pilot house. It transported passengers and, occasionally, gravel from Marble Island to Goodsell Point. The gravel was then loaded into wagons and taken to build the road by Munson Flats. (Courtesy of Joyce Sweeney.)

This camp was built in the late 1700s off Porters Point Road. It was named "the Elms" for the elm trees (later stricken with Dutch elm disease) located in front on the road. When the elms died, the camp's name changed to "Lonach," the battle cry of the Forbes family. Renovated and expanded, the house was later purchased by John and Barbara Sowles. (Courtesy of Barbara Sowles.)

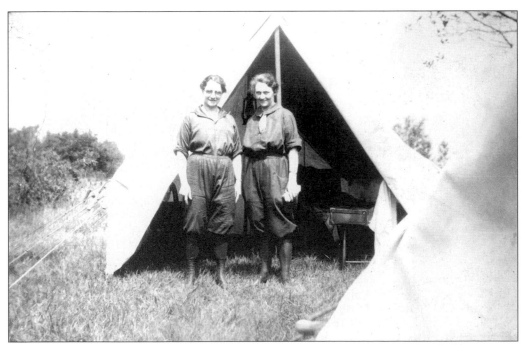

Barbara Sowles's mother Gladys (right) is shown with great-aunt Marion Forbes (left) at a camp on the shore of Lake Champlain c. the 1920s. (Courtesy of Barbara Sowles.)

This home on Porters Point Road was typical of those found on the lakeshore. It was built in the early 1900s as a summer camp by the Kenneth Forbes family. (Courtesy of Barbara Sowles.)

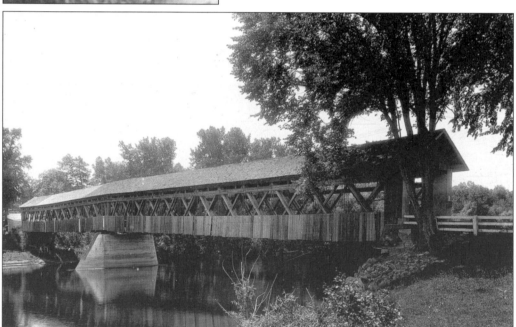

The Heineberg Bridge is shown in all its glory. It spanned the Winooski River connecting Colchester to the new north end of Burlington. The story behind the name is that Dr. Bernard F. Heineberg, a famous area physician who lived on Colchester Point, was called in 1853 to deliver a new baby on the Burlington side. The bridge had not yet been dedicated, but duty called and he became the first to cross it, thus the name Heineberg Bridge. Nine years later, the bridge burned and reconstruction of a new bridge began. (Courtesy of Barbara Sowles.)

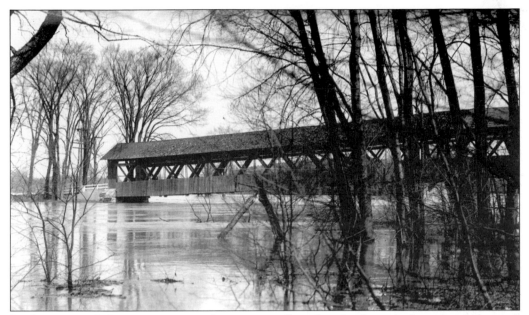

In the spring of almost every year, the river overflowed its banks and often closed the road leading to the bridge on the Colchester side. This photograph, taken on April 18, 1933, at 6:30 p.m., shows a rising river. (Courtesy of Barbara Sowles.)

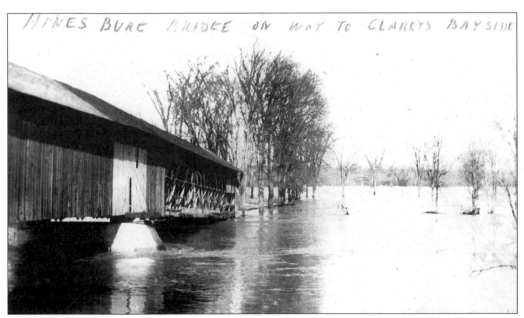

HINES BURG BRIDGE ON WAY TO CLANEYS BAYSIDE

The Heineberg Bridge is shown during the flood of 1927 on November 3 and 4. (Courtesy of Joyce Sweeney.)

Believe it or not, Colchester's lakeshore at the end of Colchester Point Road was home to beautiful sand dunes, shown here in 1950. Pat Porter recalls that her father-in-law charged couples $5 to pull them out when they parked at the dunes and got stuck. Today, a multitude of small camps has virtually obliterated these dunes. (Courtesy of Pat Porter.)

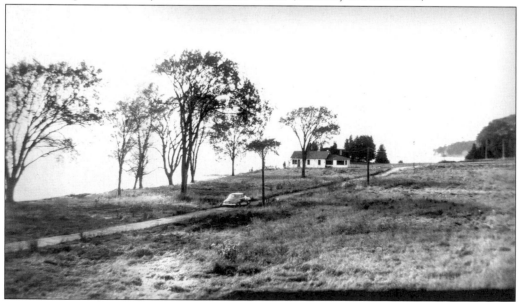

This photograph shows the barren surroundings of this Colchester Point area. The Porter family, who arrived at the outset of the 1800s from Connecticut, established a horse ferry from Porters Point across to North Nero. (Courtesy of Pat Porter.)

A two-horse ferry is illustrated here with a drawing of the remains of one located in Lake Champlain. Don Porter Fuller, who has researched his family's history in Colchester, floats the theory that the horse ferry found some years ago in Lake Champlain belonged to his family.

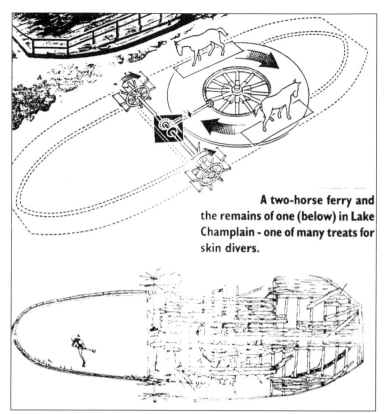

A two-horse ferry and the remains of one (below) in Lake Champlain - one of many treats for skin divers.

When the Rutland Railroad came in 1900, it crossed the Porter land on its way to Mills Point and on through the islands, beginning with South Hero, and up to Canada. Today that rail bed has been turned into a bike path, and the area is known as Colchester's Causeway Park. From the bridge shown here, local children were known to throw turkey eggs at passing trains. (Courtesy of Pat Porter.)

The turkey eggs came from the Porter farm that raised between 5,000 and 6,000 turkeys in this turkey barn, which was located at the junction of the two point roads—Mills and Colchester. (Courtesy of Pat Porter.)

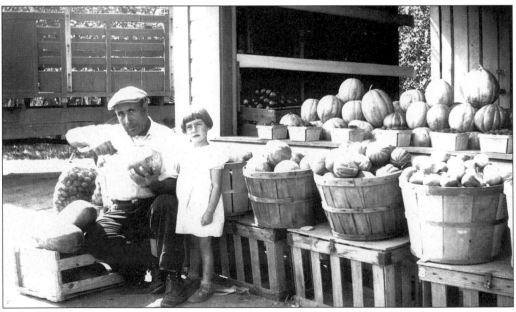

Peter Brigante started vegetable farming in the early 1920s on Malletts Bay Avenue. His sons and their families continue the tradition today. Peter is shown here in 1927 with his daughter Frances, about four years old. (Courtesy of Lorraine and Cosmos Brigante.)

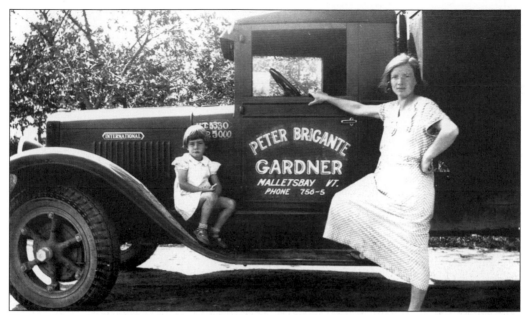

Cecilia Brigante stands by the family delivery truck with her daughter Frances in 1927. Brigante family farms continue to thrive in the Malletts Bay Avenue and Blakely Road area of town. The Shadow Cross Egg Farm remains in the Leonel Paquette family, with his son and grandson now running the business. Sam Mazza's farms, greenhouses, and bakery prosper with the help of his four daughters and son-in-law Gary Bombard. (Courtesy of Lorraine and Cosmos Brigante.)

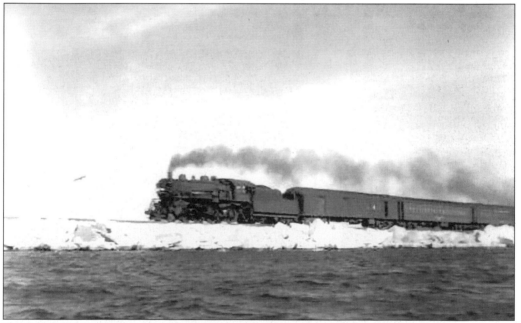

The "Island Line" steams across the causeway from South Hero to Burlington. Built in 1900 by the Rutland Railroad, the rail bed stretched six miles across the lake over a marble causeway with trestles and four drawbridges (which were manually operated), all built in one year's time. Service began from Burlington to Alburgh (yes, there was an *h* on the first train schedule) on January 7, 1901. It later continued on to Montreal. (Courtesy of Local Motion Trails and Bikeways.)

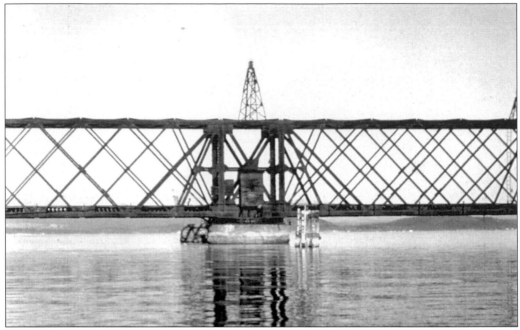

One of the swinging drawbridges on the three-and-a-quarter-mile causeway made of rip-rapped marble across Malletts Bay connected Colchester to South Hero. The project cost the railroad approximately $1 million and employed 500 men. Steel rails, steam drills, hoisting machines, boiler dump cars, plates, and ties were moved over the ice from Plattsburgh. (Courtesy of Local Motion Trails and Bikeways.)

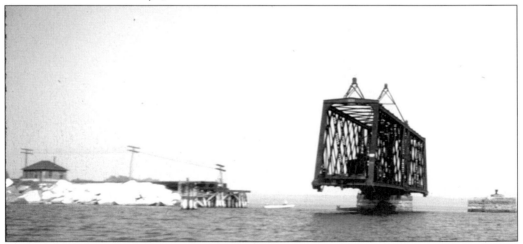

Draw tender George Sorrell recalls, "We lived in a 3-room house. . . . The first thing you had to do was unlock the bridge; it was all interlocked electrically, run by batteries. Then you put your signals on. Almost a mile either side of the bridge if a train came along and hit this one piece of track it put the lights on, a green over red. But if he got two reds right above the other he'd know the bridge was open and he'd cut his speed down so that when he got to the 'home signal,' which is 300 feet from the bridge, he'd stop there and stay there until we got the bridge closed and locked and we'd throw the levers and he's get a green signal." Brian Costello of Local Motion says they hope eventually that a replica of the draw tender will be built at the cut as a rest area. (Courtesy of Local Motion Trails and Bikeways.)

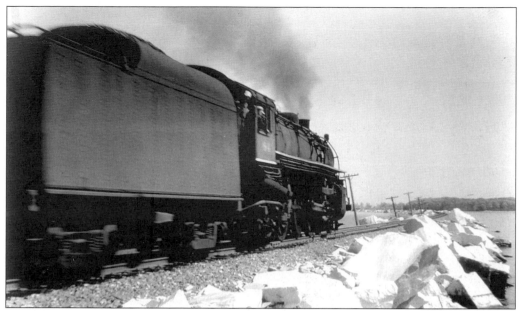

This train is headed for Colchester. The Island Line service continued until 1963, when the Rutland Railroad called it quits. The state of Vermont bought the rail beds and removed the tracks. Where once a mighty steam train roared, a quiet bike ferry provided by Local Motion, a nonprofit bike path developer, now occasionally carries cyclists across the "cut" to South Hero and beyond. (Courtesy of Local Motion Trails and Bikeways.)

In the area identified as Malletts Head, or Headland, early owners included the Winooski Marble Company and the Ragan (also spelled Reagen and Regan) family, who farmed the area. The dolomite rock found here attracted the interest of a group of promoters who acquired all rocks, stones, and quarries on the headland, Marble Island and Newton's Point (later called Coates Island), and the ledges east of Bean Road. (Courtesy of Barbara Sowles.)

Later called Winooski marble (the dolomite was red in color; others were a shaded green), it was easily split and loaded onto vessels pulled alongside the cliffs. Colchester marble was used in the Capitol, in Washington, D.C. (Courtesy of Barbara Sowles.)

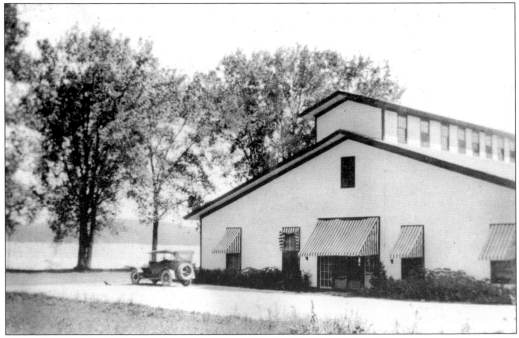

The marble mill was later sold at auction and the buildings converted to recreational use in the early 1900s. For years, the resort was a haven for weddings and other special events and offered golfing, tennis, and water activities. It has fallen on hard times in recent years and is now being developed into private townhouses and condominiums. (Courtesy of Barbara Sowles.)

Other early businesses included this store, located across from Holy Cross Roman Catholic Church on Church Road. Jim Collins (shown here on the left) remembers that, in the late 1920s, Texaco gas cost $1 for seven gallons. Irene Collins Parsons is behind the store sign where home canned goods (made in the canning kitchen next door) were sold mostly to the summer tourists living in the lakeshore camps. (Courtesy of Pat Carty and Sue Parsons Bouchard.)

The store is no longer operating but is today still owned by Roland and Pat Parsons Carty, granddaughter of the store's owner. Their next-door neighbor, the Clover House Restaurant, which opened in the mid-1920s, still operates as an eatery. The owners were Frank and Mae Francis. Their daughter Betty Francis Limoge is pictured here. Other landmark businesses in Malletts Bay since at least the mid-1900s include Hazelett Strip-Casting, Mazza's General Store, Shadow Cross Egg Farm, the Brigantes and Sam Mazza vegetable farms, Thibault Brothers Dairy Farm, a station built by WCAX in 1941 (sold to WVMT in 1963), and Broadacres Bingo. (Courtesy of Pat Carty and Sue Parsons Bouchard.)

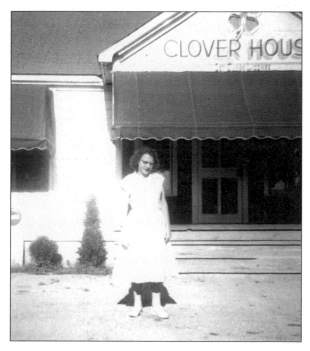

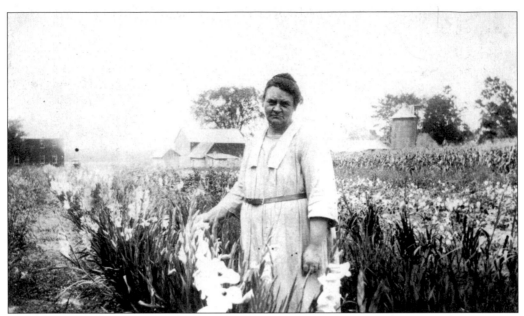

In the late 1930s, Jennie Cook Parsons raised flowers on the corner of Parsons Road and Macrae Road. She sold her peonies, asters, and gladiolas to local florists. (Courtesy of Pat Carty and Sue Parsons Bouchard.)

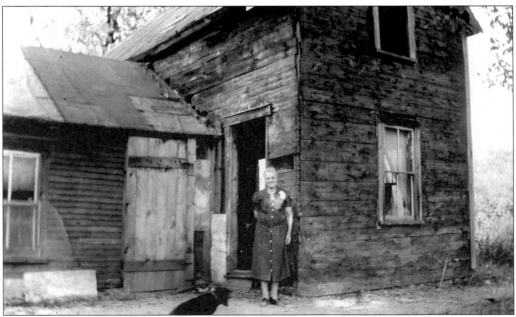

Mabel Scribner and her dog Patsy are pictured by their home on Williams Road c. 1940. The home dates back to the late 1800s. (Courtesy of Gloria and Charles Scribner.)

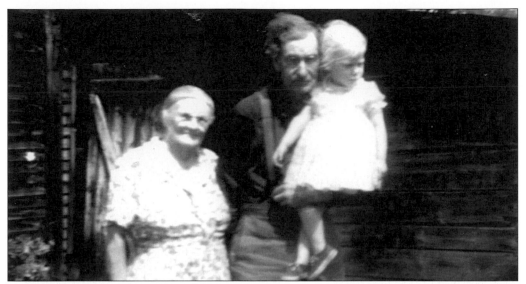

Ernest and Edith Smith are pictured *c.* 1960 with their granddaughter Helen. The Smiths, on whose property the Smith Estates are now located, lived in a small wooden house across from the lake on Lakeshore Drive. (Courtesy of Gloria and Charles Scribner.)

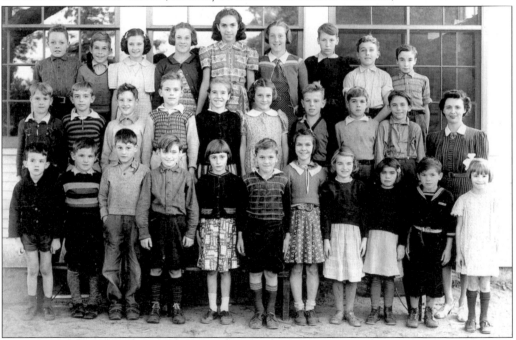

In this *c.* 1930s view, students pose by the Blakely School (now a private home), located on the corner of Lavigne Road and Blakely. From left to right are the following: (front row) Frank Stalker, ? Lavigne, Donald Angelano, Clayton Landry, Frances Brigante, John Mazza, Irene Lavigne, Rose Williams, Betty Williams, Leon Williams, and unidentified; (middle row) Earl Marshall, Bert Gardner, Robert Angelino, Donald Gardner, Dorothy Stone, Rita Angelino, Joe Lomartire, Joe Mazza, and Lawrence Cook; (back row) Charles "Eddie" Scribner, Paul Stone, Beatrice Landry, Gloria Angelano, Ethel Gardner, Amelia Angelano, Ray Marshall, Frank Mazza, and Ray Landry. (Courtesy of Gloria and Charles Scribner.)

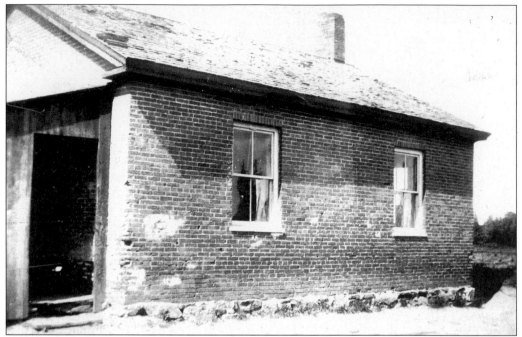

The original Porters Point schoolhouse, built in 1809, is shown here. In 1900, there were 33 students in this building. In 1922, there were 50 pupils attending. Clara E. Wright recalled that when she first visited it in that year Muriel Douglas was the teacher. Three children were sitting in seats built for two and others used stools and chairs. There were nine grades. (Courtesy of the Colchester Historical Society.)

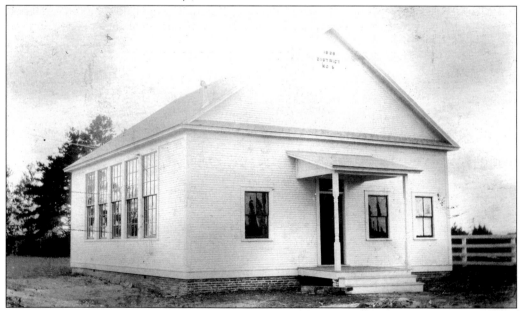

In 1926, a new school building was built on Porters Point Road and, in the same year, won the Proctor prize of $100 for being a superior school. It was later enlarged in 1938 to a two-room schoolhouse. A further enlarged building today serves approximately 288 students, hosting Early Essential Education through grade two. (Courtesy of the Colchester Historical Society.)

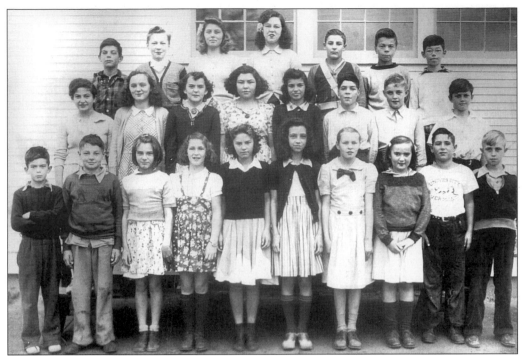

These are Porters Point students of the early 1940s. From left to right are the following: (front row) Donald Verroneau, John Porter, Doris Foley, Nancy Hines, Shirley Bean, Joyce Gay, Jackie Doenges, Sue Parsons, Edward Proulx, and James Gay; (middle row) Elizabeth Warner, Betty Parsons, Pat Parsons, June Cross, Drucilla Porter, Andy Weatherwax, Raymond LeClair, and Maurice Bean; (back row) Raymond Bessette, Kermit Doenges, Betty Bosley, Marion Fortin, Frederick Griffith, Paul Verroneau, Kenneth Bosley. (Courtesy of Pat Parsons Carty and Sue Parsons Bouchard.)

Shown c. 1945 as young women growing up in Malletts Bay are, from left to right, sisters Betty (LeBlanc), Pat (Carty), and Sue (Bouchard) Parsons. (Courtesy of Pat Parsons Carty and Sue Parsons Bouchard.)

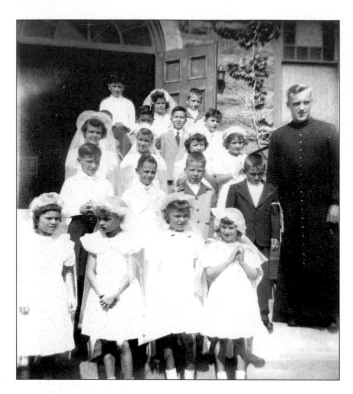

Fr. Joseph Joy is pictured in 1953 with a Holy Communion class on the steps of Cloarec Hall, which was built as the first chapel to serve Roman Catholics living in Malletts Bay. It was completed in 1915. The first pastor was Msgr. Jerome Cloarec, who shepherded the entire project and was said to have even paid for much of its construction with his own money. For years, it was the only church in the Malletts Bay area. Cloarec Hall still stands and was joined by a new church building in 1967. Other churches located in the Bay area today include St. Andrew's Episcopal Church on Prim Road and the Malletts Bay Congregational Church on Lakeshore Drive West. (Courtesy of Audrey DeForge.)

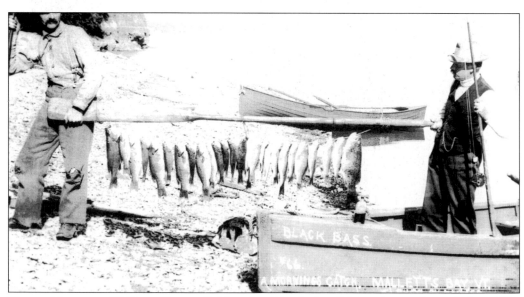

Pictured here are William Coates (left) and a friend after fishing for smallmouth bass. The photograph was taken at Gravely Beach in the Malletts Head and Marble Island area c. 1920. Year-round fishing continues today on the lake that hosts several national and local fishing derbies. (Courtesy of the David Coates family collection.)

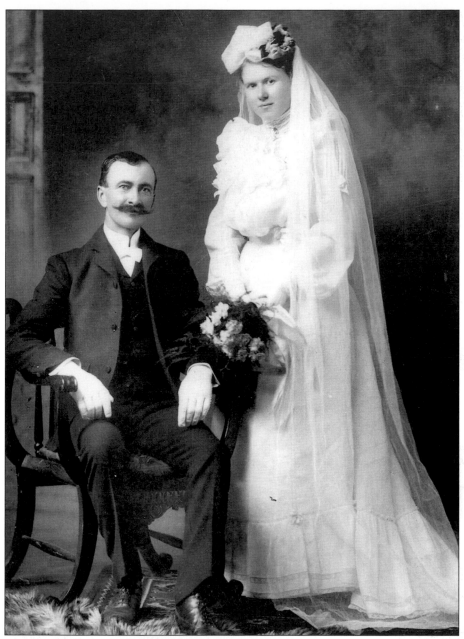

William (Gampy to his family) and Marie (Gram) Coates are pictured on their wedding day, August 29, 1903. They were married in the farmhouse he built in 1896 on Coates Island. According to great-grandson David Coates, the 80-acre island was originally bought by his family in 1872, when it was called Munson's Island after William D. Munson, who was then the owner. Coates says, "Gampy did everything to make a living. . . . He started the marina (called Coates Island Marina that continues today), conducted fishing trips (one time taking circus magnate Clyde Beatty out to fish), sold his produce in Burlington (from a garden located where Rozzi's Restaurant is today), was a cemetery commissioner who actually dug graves (at $5 a piece) and bought stock in Iroquois Power Company (now known as Green Mountain Power)." (Courtesy of the David Coates family collection.)

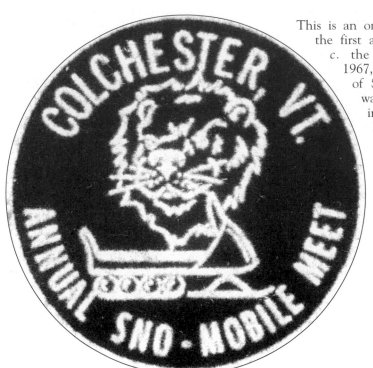

This is an original decal from one of the first annual snowmobile meets c. the 1960s. In the fall of 1967, the Vermont Association of Snow Travelers (VAST) was organized in Colchester in the then Grand View Motel on Roosevelt Highway. (Courtesy of Steve Pecor)

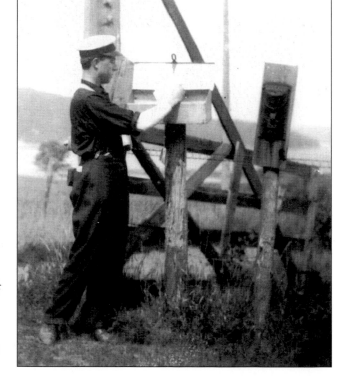

A postman delivers mail to the mailbox at the end of Island Road c. 1930. The other box belonged to the Brownell family, who lived on the opposite side of the road. Colchester continues to offer rural delivery, allowing residents to post letters from their mailboxes. (Courtesy of the David Coates family collection.)

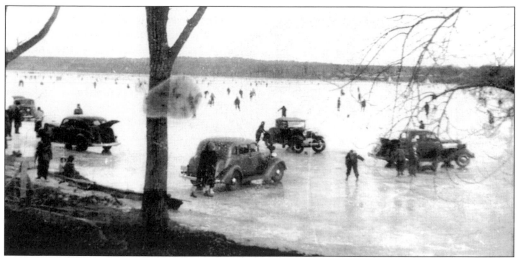

Cars and skaters are shown on the bay on the east side of the island where the Malletts Bay Boat Club is today. Driving, skating, ice fishing, and the like still take place on the west side of the island where the state fishing access is now located. The "island" is no longer an island but is instead connected to land by a causeway, built c. 1896. (Courtesy of the David Coates family collection.)

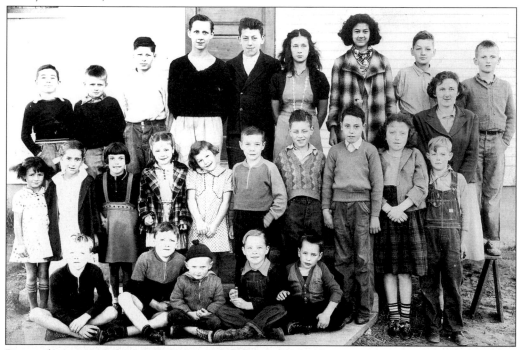

Pictured c. 1940 is the Malletts Bay Schoolhouse, located across the road from Coates Island next to what is now the Malletts Bay Cemetery. From left to right are the following: (front row) Bobby Brownell, unidentified, David Coates, F. Goyette, and P. Roberts; (middle row) P. Francis, Margarite Majorin, unidentified, Gloria Francis, Thelma Blair, George Roberts, unidentified, unidentified, Mary Lou P., and unidentified; (back row) Ken Fraser, ? Coates, unidentified, Corky Brownell, Bill Prim, ? Downs, unidentified, Bat Downs, teacher Mrs. Cook, and Billy ?. (Courtesy of the David Coates family collection.)

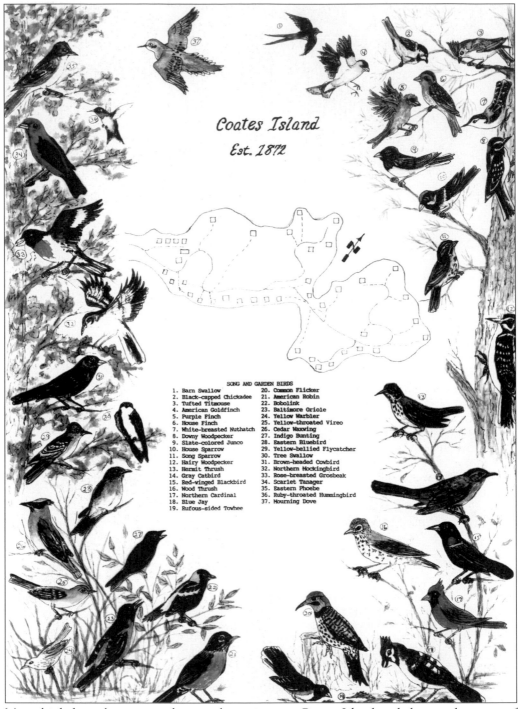

Many birds have been spotted as regular visitors to Coates Island and thus to the town of Colchester. This illustration was done by Marilyn Cadwell, a cousin of David Coates. (Courtesy of the David Coates family collection.)

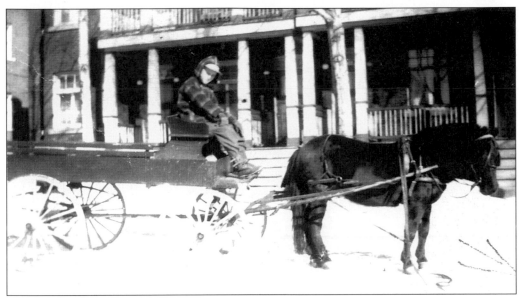

William I. Coates Jr. is probably delivering fish to the Fort Ethan Allen area *c.* 1925. (Courtesy of the David Coates family collection.)

The Colchester Lighthouse was built in 1871 to warn sailors of the dangers of three treacherous shoals—Colchester Reef, Colchester Shoals, and Hogback Reef. It was expected to protect the shipping lane to Burlington that saw barges with tugs, schooners, pin-plats, rafts and later steamboats. It is said the lumber trade in the late 1800s created sufficient traffic in this area alone to warrant the building of the lighthouse. Quite roomy, the structure had four bedrooms (one keeper's wife gave birth on the island), a kitchen and sitting room and toilet room downstairs plus a basement. A four-foot walkway surrounded the house. It was decommissioned in 1933 and replaced with an automatic electric beacon. The actual Colchester Lighthouse was relocated to the Shelburne Museum in 1952. (Courtesy of the Colchester Historical Society.)

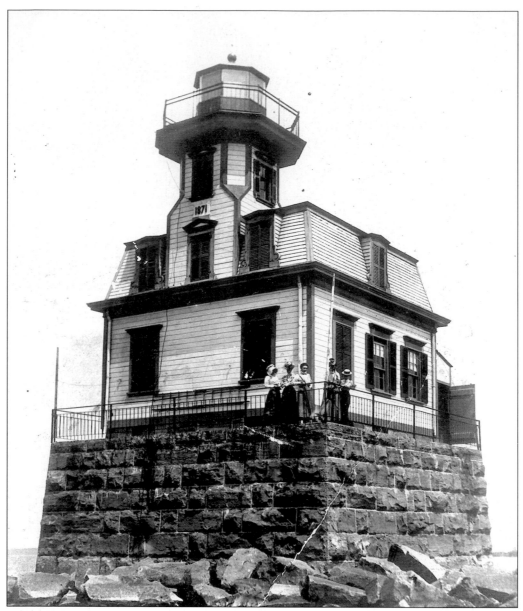

Albert Hunter, while working as a hired hand for Walter M. Button, who was the official lighthouse keeper, was assigned by Button to maintain the lighthouse. He dutifully kept a daily log for nine years while there. Here are but a few of his reflections: "January 1, 1899. 12:01, 3 degrees Wind N light. A happy New Year to everyone. May 10, 1899 It was quite sunny and I could see very well over to Grand Isle where the new railroad is being built (the "Island Line"). I could see the steam shovel work as well as hear it and also the pile driver. This evening fires are burning across the lake alongside of the railroad. They look quite cheerful and seem almost like company." His last entry before dying on May 31, 1907, read, "May 24, 1907, Cold and warm. Pete Bessette finished plowing Chet's garden and planted 6 rows of Gold Coin potatoes in a.m. Made papering board and got ready to paper Chet's sitting room and found we hadn't enough so partly painted the s-room. Went over to Henry's this evening. Feel pretty tired and nearly used up." (Courtesy of the Shelburne Museum.)

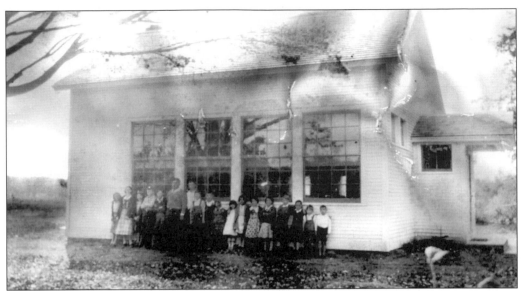

The Blakely School, in 1934, was located on the corner of Lavigne and Blakely Roads. The school is now a private residence. (Courtesy of the Colchester Historical Society.)

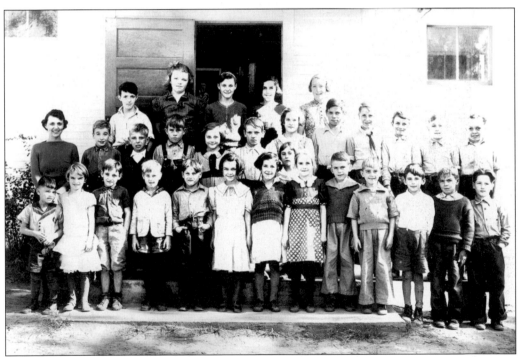

A Blakely School class poses in the 1930s. From left to right are the following: (front row) Leon Williams, Rose Williams, Clayton Landry, Earle Marshall, Irene Lavigne, unidentified, Frances Brigante, Dorothy Stone, Donald Gardner, Bert Gardner, Lawrence Cook, Joe Mazza, and Robert Angelino; (middle row) Mrs. Keesic, Ray Landry, Joe Lamartire, Paul Stone, Rita Angelana, James Zeno, Gloria Angelino, Charlie Zeno, Roy Marshall, John Zeno, Frank Mazza, and Eddie Scribner; (back row) unidentified, Thelma Wright, Ethel Gardner, Amelia Angelano, and unidentified. (Courtesy of Gloria and Charlie Scribner.)

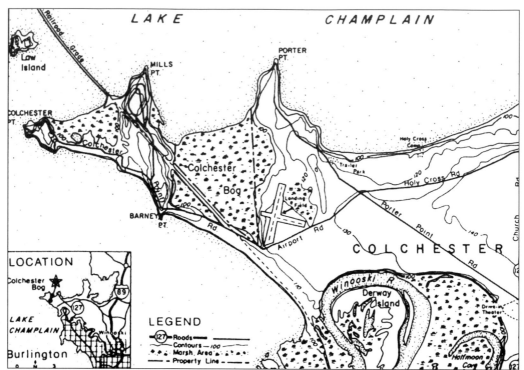

It is difficult to believe, but the Colchester Bog has been determined by the University of Vermont to be at least 9,000 years old. The 200-acre peatland is protected as not only a state landmark but a national one. It is a particularly unique natural area because of its relationship to Lake Champlain. According to the University of Vermont's Ian Worley, "it is a natural library recording the history of the lake and the mouth of the Winooski since the last day the ice left—10,000 to 12,000 years ago." The bog is located off Colchester Point Road next to the town's Airport Park.

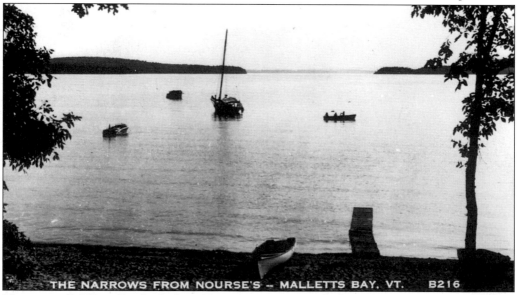

This view of Malletts Bay looks from Nourse's Corner on Lakeshore Drive toward the outer bay. (Courtesy of Joyce Sweeney.)

Four

FORT ETHAN ALLEN

For years, sections of Colchester did not share a common zip code. Instead, much of the town used the zip assigned to Winooski—05404. Nowhere did that seem more natural than the area now generally called the Fort or Fort Ethan Allen. For most of Colchester, that zip code changed to 05446 in 1978, with the St. Michael's College campus only changing in 1989. Thousands of St. Michael's College alumni will still tell you their alma mater is located in Winooski. Not true.

The St. Michael's campus, the old Fort Ethan Allen with its current assortment of prospering small businesses, the Lime Kiln Bridge (connecting Colchester to South Burlington), Camp Johnson, and the Fanny Allen campus of Fletcher Allen Health Care, constitute this area of town. It is the only area in town served by a bus line. For purposes of this book, the Fort Ethan Allen area is north of the Winooski River to Severance Road, east from the city of Winooski to the Essex border. Approximately 1,000 people reside in this area, bolstered by more than 2,260 workers who commute there daily from all areas of Chittenden County and beyond.

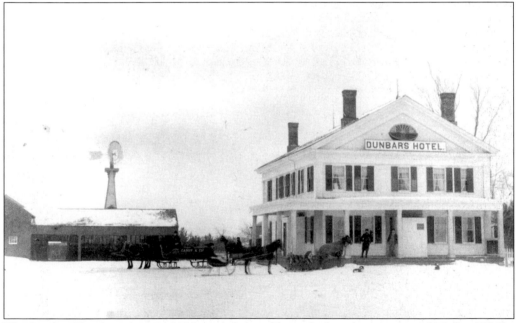

The Dunbar Hotel, in the late 1800s, was donated by an Irish immigrant named Michael Kelly, who had received an inheritance from his employer Mary Fletcher. He transferred title of the property to Bishop Michaud in 1892, stipulating that the hotel be used as a hospital. The Religious Hospitallers of St. Joseph (founded by a Jerome le Royer de la Dauversiere in the small French village of LaFleche, France) were sent to Montreal to form a Hotel Dieu (House of God) and later settled in Colchester. (Courtesy of the Religious Hospitallers of St. Joseph.)

Pictured here is Fanny Allen (1784–1819). To understand the spirit of the Fanny Allen Hospital, one must understand the spirit of its namesake and the sisters of the Religious Hospitallers of St. Joseph whom she so loved. Frances Margaret Allen was the daughter of Ethan Allen. She converted to Catholicism following an experience she had at 12 years of age, walking along the Winooski River. She became frightened of something, and a passerby "saved" her. Later, she again saw the face of the man who had helped her that day: St. Joseph. She broke her engagement to a recent university graduate, converted, and worked alongside her sisters in faith who nursed the wounded soldiers from the War of 1812. She died of tuberculosis at only 35 years of age. Those sisters, inspired by her memory, came to Vermont to found a hospital. (Courtesy of the Religious Hospitallers of St. Joseph.)

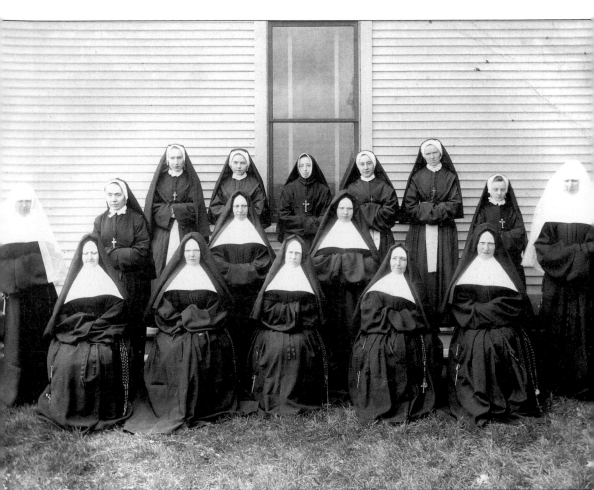

Bishop deGoesbriand, who foresaw a need for a hospital for the sickly poor and a retirement home for priests, contacted the sisters. With their faith and the memory of their beloved Fanny Allen, they agreed to come. In May 1894, they arrived by train in Essex Junction to begin converting the Hotel Dunbar into Hotel Dieu, later to become the Fanny Allen Hospital. The Religious Hospitallers of St. Joseph are pictured in September 1899. From left to right are the following: (front row) Sister Sheere, Sister Campbell, Mother Renaud, Sister Gravel, and Sister Milne; (middle row) Sister Rooney, Sister Catherine, Sister Philomena, Sister Exea, Sister Evangeline, and Sister McDonald; (back row) Sister John of God, Sister Sweeney, Sister Isabella, Sister McLeod, and Sister Flynn. (Courtesy of the Religious Hospitallers of St. Joseph.)

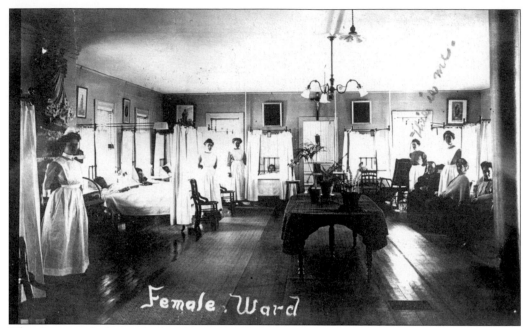

This photograph shows the female ward, called St. Mary's Ward, c. 1910. According to hospital administrator Sr. Irene Duchesneau, "the Sisters were first expected to care for unwed mothers, people with the 'pest' (typhoid, cholera and smallpox) and lunatics." (Courtesy of the Religious Hospitallers of St. Joseph.)

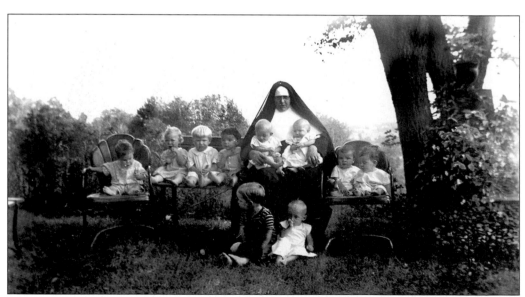

Sr. Mary Loretto recalls that the sisters cared for abandoned and illegitimate children as well, and because "it was taboo, very few records were kept." Sister Loretto is shown here in the 1930s. (Courtesy of the Religious Hospitallers of St. Joseph.)

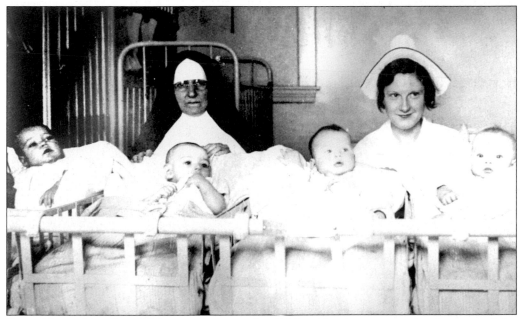

Sister Mary of the Scared Heart is shown *c.* the 1930s with a lay nurse caring for some of the orphaned children who were left at the hospital. The hospital opened its school of nursing in October 1899, with just eight students. The nursing school harkened back to the earliest work of the sisters and Jeanne Mance, the first lay woman to devote herself full-time to nursing in North America. (Courtesy of the Religious Hospitallers of St. Joseph.)

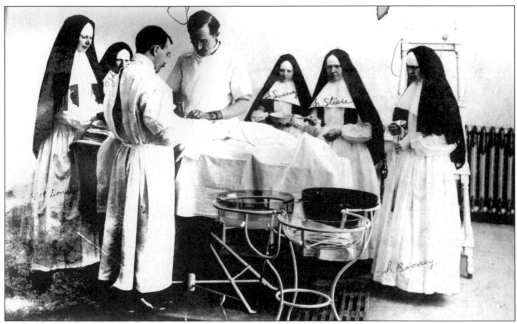

Sisters of the Religious Hospitallers of St. Joseph assist in the operating room in the early 1900s. (Courtesy of the Religious Hospitallers of St. Joseph.)

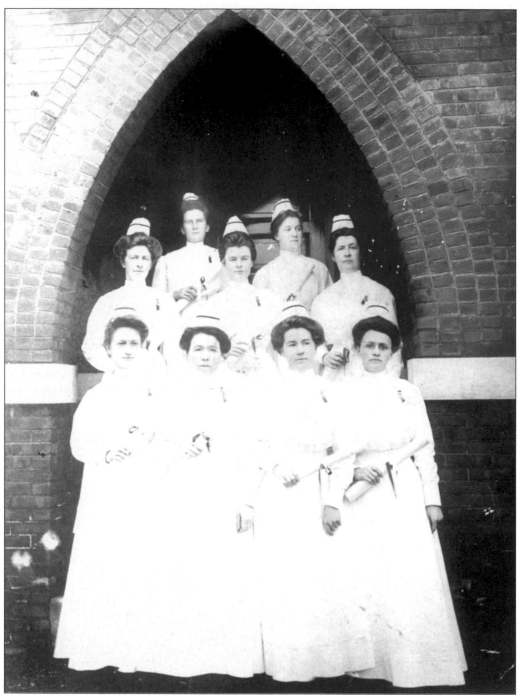

Here we see the graduates of the class of 1910 from the Fanny Allen School of Nursing. Students later took some of their courses at St. Michael's College (c. 1926). In 1955, the nursing school merged with the Bishop DeGoesbriand Hospital and later became the Jeanne Mance School of Nursing. A school of practical nursing opened on the Fanny Allen campus in 1957 and was called the Fanny Allen Memorial School of Practical Nursing. (Courtesy of the Religious Hospitallers of St. Joseph.)

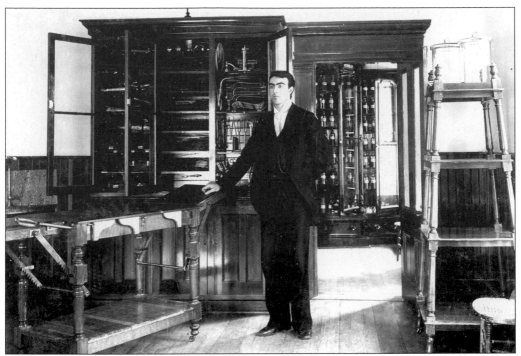

An early operating room is shown here, with the pharmacy beyond the doorway. The *Burlington Free Press* wrote of the "splendid staff of physicians for the new institution" that included P.E. McSweeney, whose family supported the hospital for more than 100 years. (Courtesy of the Religious Hospitallers of St. Joseph.)

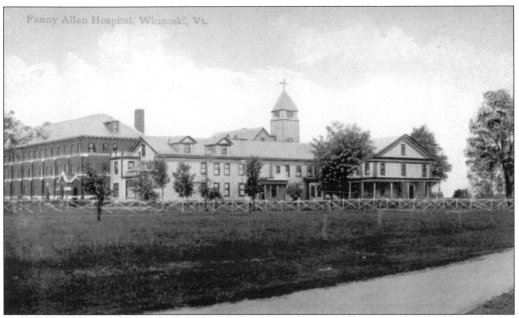

The Fanny Allen Hospital and convent is shown here in the early 1900s. (Courtesy of the Religious Hospitallers of St. Joseph.)

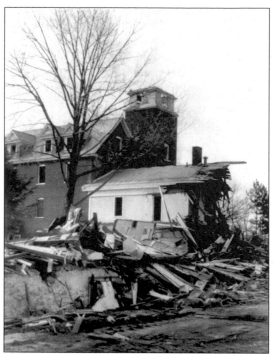

Upon the completion of a new hospital, the old hospital building, shown here, was demolished in 1977. In 1995, the Fanny Allen Hospital merged with the Medical Center Hospital of Vermont. Sister Duchesneau explains that "the purpose of this partnership is to serve the public better. It is consistent with our RHSJ's mission—'to be witness of the love of God in a broken world, called to live in collaboration with others in order to serve the poor, the sick and the most needy,' and together (the MCHV plus the University Health Center) we will do that." The new name is Fletcher Allen Health Care, with the Fanny Allen campus offering ambulatory surgery, a walk-in center for minor emergencies, and acute in-patient rehabilitation. (Courtesy of the Religious Hospitallers of St. Joseph.)

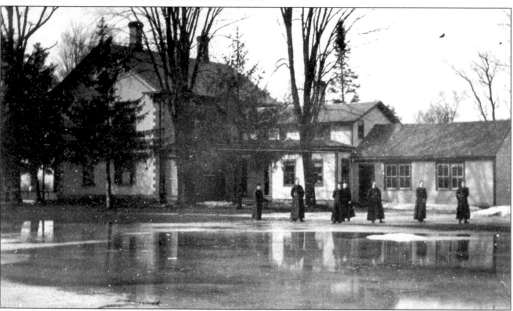

The same Michael Kelly who had negotiated property for the Fanny Allen Hospital sold his property across the road to the arriving Society of the Fathers of St. Edmund. Originally founded in France as the Priests of the Sacred Heart, they sought a new home in the late 1800s after the French government began appropriating religious orders' properties. Bishop deGoesbriand was contacted to help them find refuge. Mother Renaud (Superior of the Fanny Allen Hospital) and a Winooski Pastor, Fr. Jean Audet, bought the property on their behalf. Shown here is the old Kelly farmhouse (1902–1903), which became St. Michael's House and then College Hall until 1924. (Courtesy of St. Michael's College.)

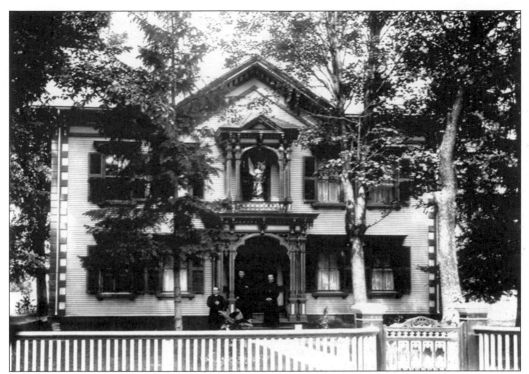

This is the front of College Hall. It was renamed Old Hall in 1924 and was later called Founders Hall. (Courtesy of St. Michael's College.)

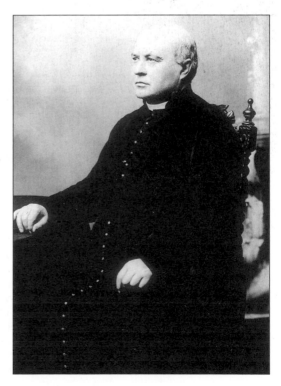

In 1904, Rev. Amand Prevel was named as the first president and superior of the community. The school opened, offering both a practical and a liberal education taught in both English and French. Thirty-five students entered that first year, 28 of them boarders paying tuition of $143. (Courtesy of St. Michael's College.)

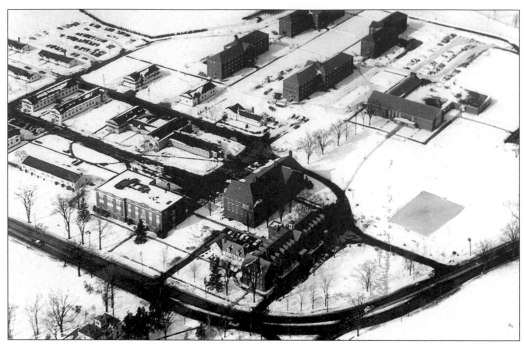

A 160-acre parcel across Route 15 was acquired through the generosity of local clergy, giving the college a 225-acre campus. (Courtesy of St. Michael's College.)

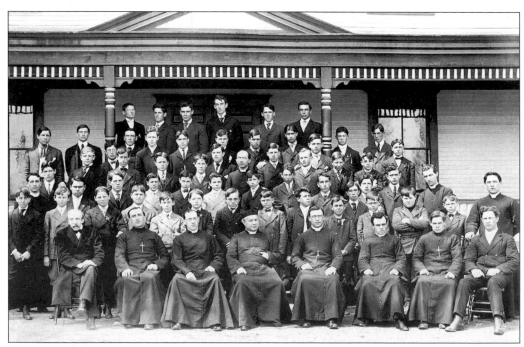

The St. Michael's College student body is shown here with faculty in the early 1900s. (Courtesy of St. Michael's College.)

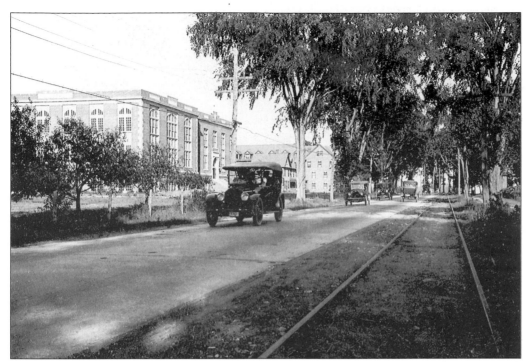

In 1929, Founders Hall was improved and Jeanmarie Hall built to hold administrative offices, classrooms, a gymnasium, and a chapel. Note the elm trees in front that no longer exist on this road, probably due to Dutch elm disease. A trolley from 1894 (run by the Military Post Railway Company) was replaced with buses in the 1940s. (Courtesy of St. Michael's College.)

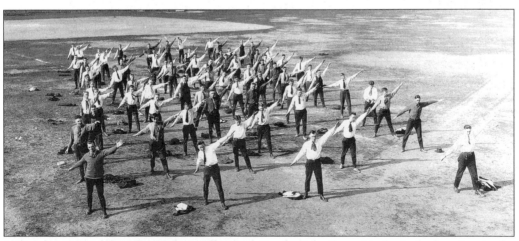

Military personnel from Fort Ethan Allen instructed Michaelmen in physical education in the 1920s. (Courtesy of St. Michael's College.)

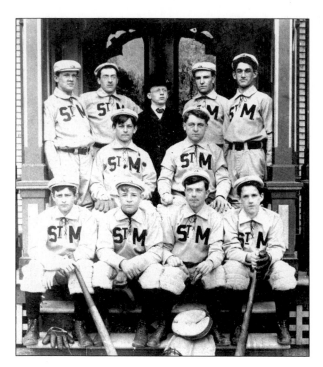

This is the St. Michael's College baseball team in the early 1900s. The school approved the admission of women in 1971. In 2003, the college had about 2,500 students (graduate, undergraduate, and part-time) and remains a small, Catholic liberal arts college.

The High Bridge, connecting Colchester to South Burlington over the Winooski River at the Winooski Gorge, was replaced in 1894 after it had been deteriorating for years. According to historical writer Ann Wetzel, a torrential rainstorm in 1830 finally washed it out, and Colchester agreed to assess a 9¢ tax on the Grand List to replace it. At the base of this bridge, a limestone quarry existed for more than 150 years. (Courtesy of Joyce Sweeney.)

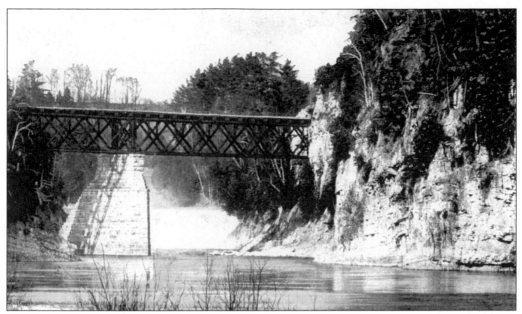

The bridge shown here replaced the High Bridge. It was an open 278- by 20-foot bridge with 76-foot-high arches above the river and also spanning the railroad tracks. Considerable repairs were made to the bridge again in 1937 according to Ruth Wright's book *Colchester: Icecap to Interstate*. The present bridge and viaduct were built in 1812 and extensively repaired in 1971 (From an article in *Look Around Colchester and Milton*, by Ann Wetzel).

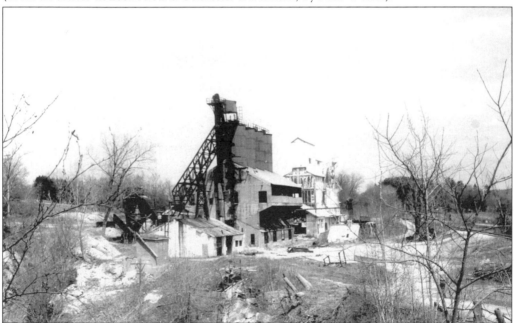

A limestone quarry has existed at the base of the bridge for more than 150 years. According to Wetzel, the Lime Company (later called the Winooski Limekiln Company), conveyed, by tram, the dove-white stone to the tops of four kilns. Annually, 250,000 bushels of lime were produced using 4,000 cords of wood to fire the kilns. The quarry closed in the mid-1900s and has since been filled in. (Courtesy of Ann Wetzel.)

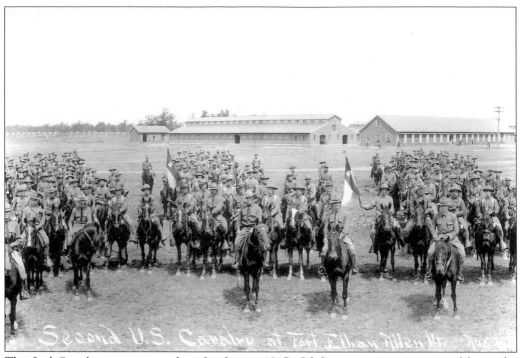

The 2nd Cavalry was stationed at the fort in 1917. Of the many troops stationed here, the famous black "Buffalo Soldiers" of the 10th Cavalry were among them. They served in the Spanish-American War and the Texas border disputes. (Courtesy of Ann Wetzel.)

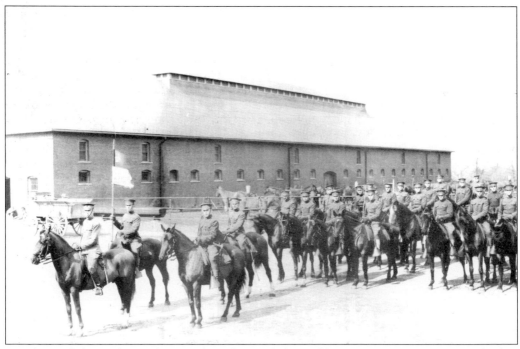

Members of the 3rd Cavalry stand in front of the stables in 1921. Not surprisingly, but interestingly, some of that land was originally owned by Ethan Allen's brother Ira.

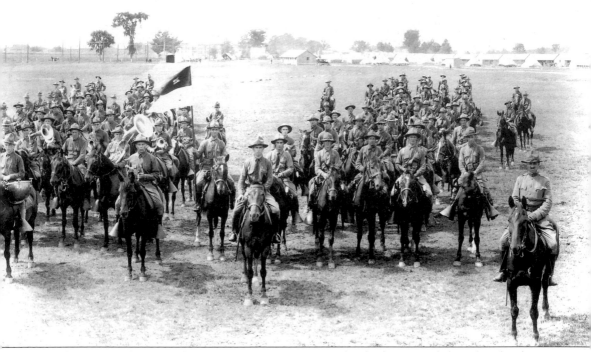

The 3rd U.S. Cavalry arrived in 1894 in two trains—one for the horses and the other for the men. On the eve of the Spanish-American War in 1898, they were transferred, and the fort became a mobilization point for the Vermont National Guard. Legislators John Stewart and Justin Morrill persuaded the U.S. Congress in 1892 that a fort east of the Mississippi near Lake Champlain had strategic military importance. The Colchester site was ultimately selected for its accessibility to railroad links extending to the south and east. Because of the stimulation it brought to the local economy, the stipulation that the land had to be donated free of charge to the U.S. government drew the energetic support of Dr. W. Seward Webb of Shelburne and the Central Vermont Railroad, who pledged money for the land purchase along with several other local businesspeople. The fort was named after the leader of the Green Mountain boys. (Courtesy of Frank vonTurkovich.)

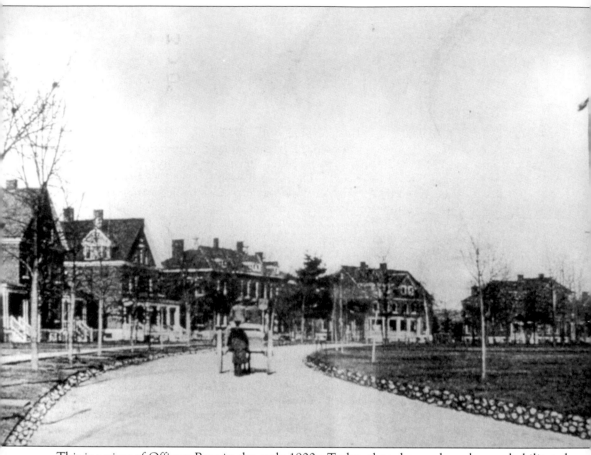

This is a view of Officers Row in the early 1900s. Today, these houses have been rehabilitated and are occupied. In the fort area, the University of Vermont and St. Michael's own several buildings; Vermont public television and radio have studios there; and the Vermont Youth Orchestra occupies a newly renovated building among a hodgepodge of many other small private businesses flourishing in buildings that generally retain their architectural integrity, and, most importantly, the spirit and energy of their earlier residents.

Five

WINOOSKI

The headlines in the *Burlington Daily News* on February 17, 1922, read, "Winooski will become a city on March 7, 1922." The article, written by H. Albon Bailey, the city's first mayor, began, "On the first Tuesday of March, the village of Winooski will become the city of Winooski, thus dividing one of the oldest towns in Vermont." The phenomenon is explained this way: "It has been recognized that the interests of industrial Winooski and rural Colchester are so different that it would be of mutual advantage to separate." (Wright, *Colchester: Icecap to Interstate.*) In *The Great Falls on Onion River: A History of Winooski, Vermont*, Vince Feeney says, "Citizens argued that supporting two local governments was inefficient, and that rural Colchester was uninterested in funding Winooski's urban needs." Politically, Winooski would be a Democratic stronghold compared to the Republican leanings of rural Colchester. It would also be "uniquely Catholic in Protestant Vermont." (Feeney.)

Winooski is an Abenaki word meaning "onion river," and scholars agree that the Abenakis spoke of a village named Winooskik on the lower reaches of the river. When Ira Allen arrived in 1772, he found a camp that belonged to a (New) "Yorker" surveyor; he and his men persuaded the surveyor to abandon the camp and to return from whence he came. Quick to recognize the potential of the land surrounding "the Falls," Allen, along with brother Ethan, Remember Baker, Heman Allen, and Zimry Allen, formed the Onion River Company. The company began farming, built a dam and gristmills, and offered other amenities to settlers, such as Fort Frederick (built in 1773) for protection and social gatherings. The area quickly became an industrial and commercial hub. When the split came, Winooski was left with approximately one square mile of land.

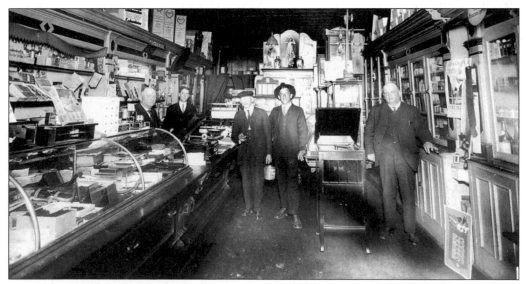

Pictured *c.* 1915 is Smith Pharmacy, on Main Street in Winooski. Behind the counter are Morris (left) and Arthur Smith.

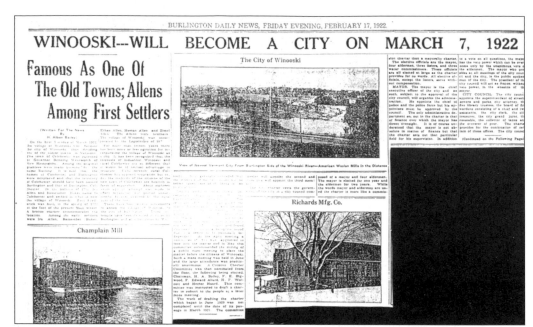

The *Burlington Daily News* headline announced the end of the union between Colchester and Winooski. At their 50th anniversary celebration in 1972, then Winooski mayor Dominique Casavant would be heard to say to Colchester Selectboard chair Henry Schaefer, "I'm not really sure this is a cause for celebration." (Courtesy of the Winooski Historical Society.)

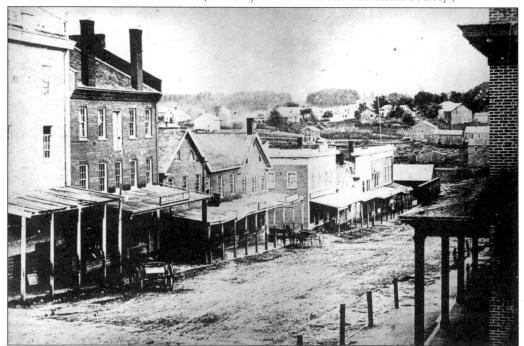

Main Street in Winooski is shown in a view looking east *c.* 1870. In January 1867, Winooski Falls would become an incorporated village within the town of Colchester. While some meetings were held in Winooski until the late 1880s, most were in Colchester Center. (Courtesy of Arthur Daley.)

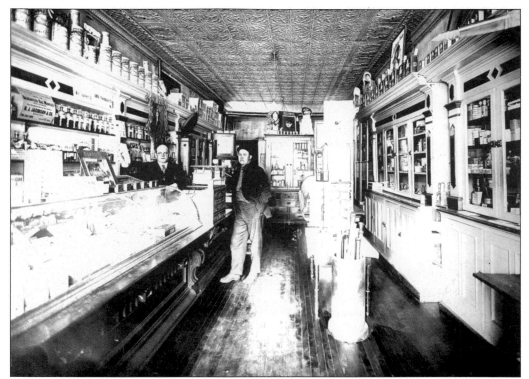

The Smith drugstore, seen *c.* the 1880s, is now Sneakers Restaurant on Main Street. (Courtesy of Arthur Daley.)

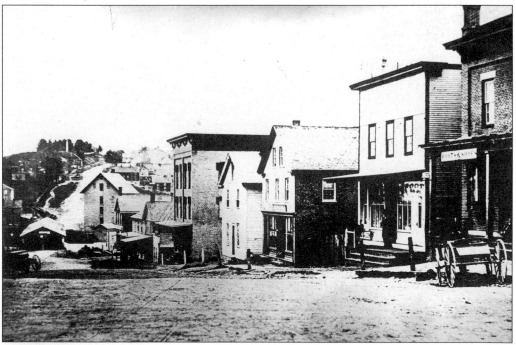

This *c.* 1870s view of Main Street in Winooski looks west. The Ethan Allen Monument in Burlington can be seen in the upper left corner. (Courtesy of Arthur Daley.)

Here is the lower Winooski Falls with the old bridge in the background and the gristmill on the right (in Burlington). (Courtesy of Joyce Sweeney.)

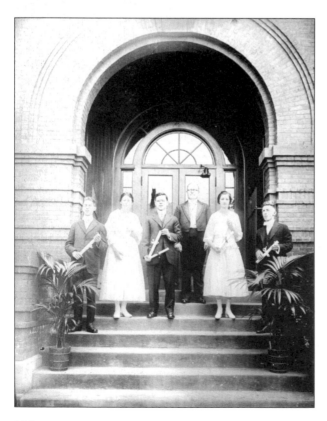

Graduates of Winooski High School pose *c.* 1915–1917. From left to right are three unidentified graduates, George Stackpole, Anna Hanson, and Hector Parizo. (Courtesy of the Winooski Historical Society.)

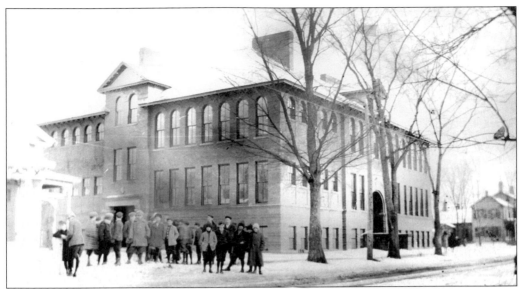

This is the Winooski School, which included the high school *c.* 1912–1913. (Courtesy of the Winooski Historical Society.)

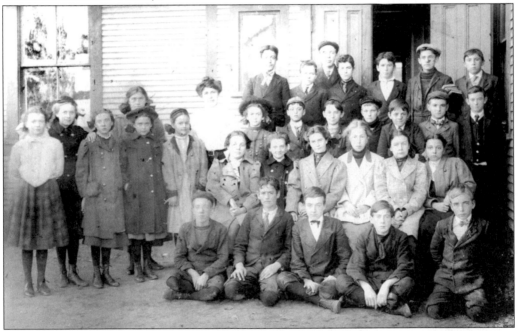

Miss Pike's class is shown at the Elm Street School, on Malletts Bay Avenue and Elm Street, *c.* 1903. Tom Fitzgerald (center, back row in hat) is shown in this photograph. He was the father of Tom and Dr. Richard Fitzgerald. The District No. 6 Winooski school would be the largest in Colchester. According to town records from 1845, this school had 176 students and paid a male teacher for 16 weeks $22 per month, a female for 17 weeks, $14.35 per month. The 1877 town report records that District No. 6 received $313.31 to educate about 265 students. In 1891, a state tax of five percent totaling $606.85 was distributed to Colchester schools, with Winooski receiving $367.76. Some $239.09 was be split between all the other 13 schools in town. (From *Colchester: Icecap to Interstate.*) (Courtesy of the Winooski Historical Society.)

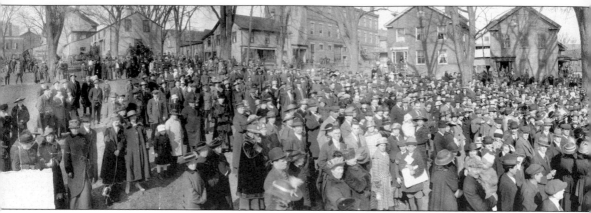

The people of Winooski are shown *c.* 1917 by the old woolen mills. Soldiers from Fort Ethan Allen are included in this unusual memento of simpler times. Today thousands of cars pass through this corner on a daily basis. The small house second from left is where Papa Frank's

This is the Winooski Block, built in 1867, as it looks today. On this location, Ira Allen had his home with an apple orchard in front that extended down to the river. Winooski, when incorporated as a city, had 795 acres. According to the census of 1900, there were 5,352 people living in Colchester. Following the split, the Colchester population fell to just 1,695 in 1922. (Courtesy of Inge Schaefer.)

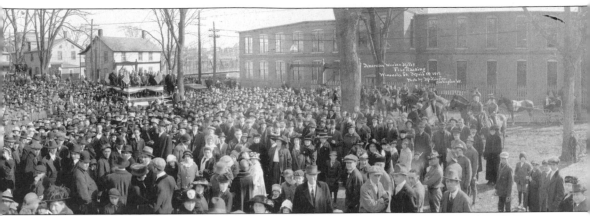

Restaurant is today. Next to that house is Corporation Hall, which has since been taken down. The flood of 1927 did heavy damage to the mills. (Courtesy of the Winooski Historical Society.)

Pictured here are the upper Winooski Falls today. (Courtesy of Henry Schaefer.)

This photograph shows some members of the Caisse Infantile of Conseil J.F. Audet of L'Union Saint-Jean-Baptiste at the entrance of the Couvent Saint-Louis on West Spring Street. The Conseil was a fraternal order. These girls were probably a girls drill team. The photograph was taken on or around June 24, 1928, on the Feast of St. John the Baptist. From left to right are Rita Villemaire, Anita DeVarney (White), Cecile Dion (Barber), Rita Boucher (Merchant), Jeannette Fregeau, Helen Marcotte (Deforge), Regina Blondin (Grilz), Lorraine Brown (Ely), Sr. Claire Picher, Claire Gravel (Kruger), Rita Fregeau (White), Claire Bouchard (Flaherty-Reilly), Aletha Gadue (Hubbell), Aline Gravel (Coffey), Madeleine Picher (Carpenter), Leona Desautels (Villemaire), and Constance Crowley (Letourneau). The industrial works first attracted French Canadians to Winooski, a trend that would continue over the next 100 years. That French Canadian influence is still evident today. (Courtesy of the Winooski Historical Society.)

THE TIES THAT BIND

While the four areas of Colchester are each distinctive in their own right, much binds the town and its people together. Town meetings and other public forums, annual sporting events, and celebrations are never in short supply. There are 17 areas of natural significance in Colchester, including the Sunny Hollow Natural area and Delta Park. The town's recreation programs are plentiful, and its primary and neighborhood parks include Airport Park with its many soccer fields where once small, private planes touched down, gassed up, and took off again. Bike paths lead riders from the bay to Colchester Village, over the causeway to the cut on Malletts Bay, or over to Burlington (when the bike ferry is operating). The Burnham Memorial Library has many outreach programs, including a new Bookmobile, and is cherished by locals who volunteer and assist financially in its support. Five school buildings—two elementary, a grade building, and middle and high school—provide a multitude of activities and learning opportunities for Colchester's 2,469 school-age children.

Colchester has eight churches of varying denominations. The Fanny Allen campus of Fletcher Allen Health Care is often more convenient than the hospital in Burlington for a minor emergency. Cultural and sporting events at St. Michael's College are available to residents, as well as the bragging rights that come with having one of the nation's finest small, private, liberal arts colleges. A military museum is located on the Camp Johnson base, home to Vermont's National Guard. Exit 16 provides a variety of large new hotels and new employers ranging from Costco, Vermont Information Processing, and Bombardier to Fox-44 TV. Colchester has more electronic media stations within its borders than any other community in Vermont. And from the beginning, Colchester's proximity to Lake Champlain and its treasured Malletts Bay has brought joy and commonality to residents in a multitude of ways through all four seasons.

The 2002 census shows Colchester with 17,167 residents, second only as a single community to Burlington.

Colchester High School's varsity Division 1 soccer teams, both girls and boys, continually do well in the state finals.

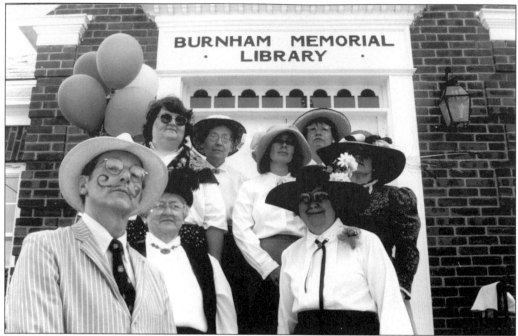

To celebrate the Burnham Memorial Library's centennial, members of the Friends of the Burnham Library and staff pose on September 8, 2001. Several activities designed to familiarize residents of an earlier time, and a tribute to the work of the King's Daughters for their efforts in the library's formation, were held. Starting with Jim DeFilippi (in front on the left) and going clockwise, we see Carol Reichard, Marcy Crocker, Erika Trudeau, Eve Duff, Pam Cushing, Betty Ellis, and Carolyn Barnes. (Courtesy of the Burnham Memorial Library.)

Natural resources abound in Colchester, as seen in this view of Colchester Pond in Colchester Village. (Courtesy of Hank Schaefer.)

Malletts Bay, on a rare morning in the fall, when temperature changes between the air and the water create a steam rising off the water, offers this haunting view with Mount Mansfield in the background. (Courtesy of Julie Weaver.)

This is the Winooski River by Macrae Road. (Courtesy of Hank Schaefer.)

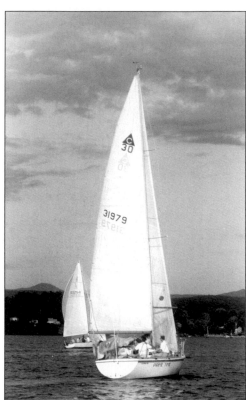

Among the many pleasures of Malletts Bay are the Thursday night races run by the Malletts Bay Boat Club. Several types of sailboat races are held throughout the summer and fall. (Courtesy of Inge Schaefer.)

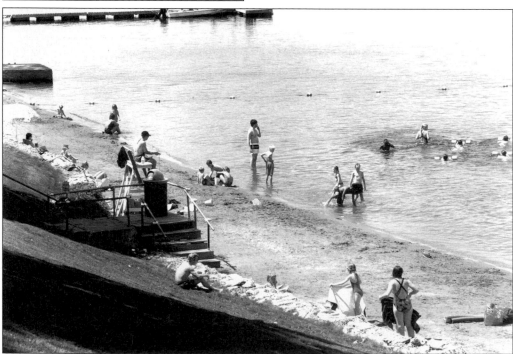

The water quality of Malletts Bay is carefully monitored with regular water testings. Swimming lessons are conducted throughout the summer by the Recreation and Parks Department.

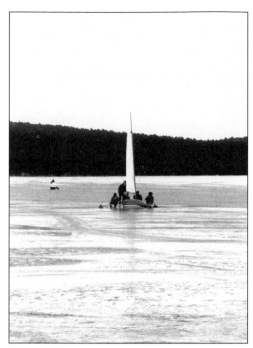

Iceboating and snowmobiling are popular sports once the bay has frozen.

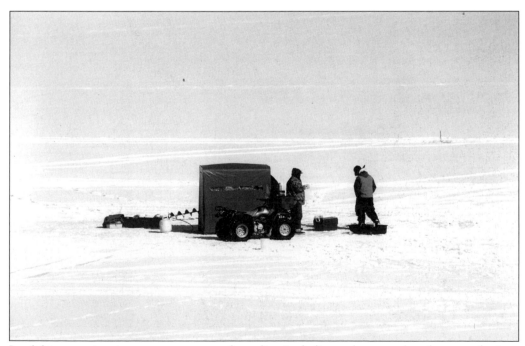

Ice fishing requires its own assortment of supplies, including a shanty and tools to cut the ice.

Motorboats come in all sizes and shapes on Lake Champlain. State, local, and national fishing derbies are held annually.

An elegant heron stands on the rocks of Rose Island next to the Cave and Marble Islands in Malletts Bay.

According to cemetery commissioner Joyce Sweeney, there are 10 cemeteries in all located in the town of Colchester. Of these, three are private with one owned by Holy Cross Church, one by St. Steven's Church in Winooski, and the last by the Religious Hospitallers of St. Joseph (located behind Fanny Allen campus of FAHC). The Colchester Village Cemetery, behind the library, the church, and the Town Meeting House (seen in the background), is on Main Street.

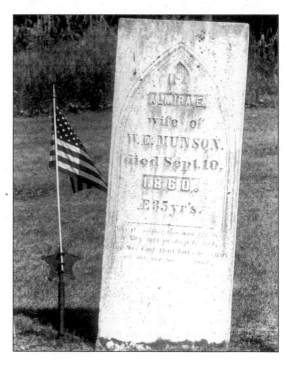

In 1913, the Colchester Cemetery Association was formed to take care of the Colchester Village, Methodist, and Munson cemeteries. In 1963, the Board of Cemetery Commissioners, to be elected by the voters, was formed to oversee the care of the town's seven cemeteries, including the three above plus the military cemetery located across from Camp Johnson, the Malletts Bay cemetery on Lakeshore Drive, the Champlain Cemetery on Jasper Mine Road, and the Merrill Cemetery opposite St. Michael's College.

Pictured here is the floating walkway into the Colchester Bog from the Airport Park on Colchester Point Road. Under the jurisdiction of the University of Vermont and protected nationally, the bog is a Vermont and Colchester treasure.

Youngsters play in the playground of Airport Park, which includes several baseball fields, a soccer field, volleyball and tennis courts, a pavilion, and a walking path.

Vermont Public Radio is located at Fort Ethan Allen in a magnificently renovated building that was once a horse stable used by the U.S. Army Cavalry. There are four other radio stations—WVMT, WXXX, WEZF, and WWPV—and four television stations—WPTV, Fox-44, VPT, and Lake Champlain Access TV. Interactive TV and the Regional Educational Television Network (RETN) are also at Fort Ethan Allen.

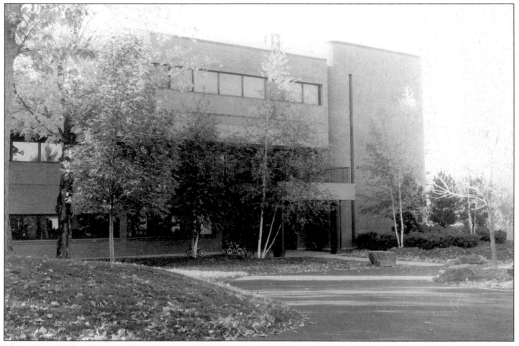

Vermont Information Processing (VIP) is just one of several companies located on Water Tower Hill by exit 16 off Route 89.

After the closing of the Winooski mills, sheep farming fell out of vogue, but sheep are returning in modest numbers. Shown here are Eugene Button's sheep on his farm on Route 7.

Many homeowners have been known to hang a pail on a maple tree in the spring. This photograph, however, was taken of the sugaring operation at Rollie and Murray Thompson's farm. While no longer sugaring, the Thompsons continue dairy farming, a family tradition of 200 years' duration. Colchester does have a maple sugaring farm on Poor Farm Road.

118

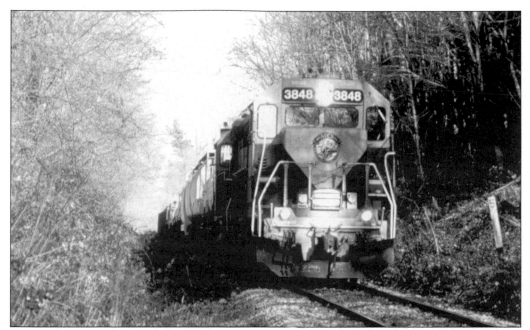

Here the New England Central Railroad (formerly the Central Vermont Railroad) travels by the Lime Kiln Bridge area. There was a time when almost every day a train went through Colchester. Now freight carrying wood chips will pass through five times a week on its way to Burlington. (Courtesy of Jim Jones.)

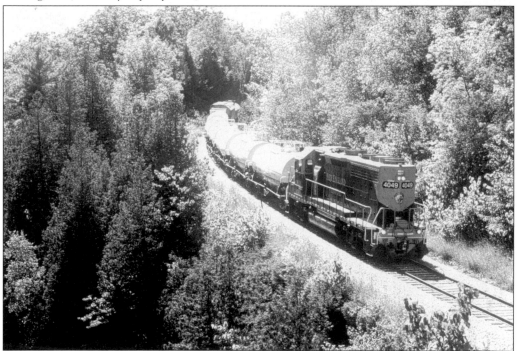

This New England Central train is traveling behind the Fanny Allen Hospital heading to Burlington. It will travel just 10 miles per hour for the seven miles into Burlington. (Courtesy of Jim Jones.)

Special events such as the Fourth of July Fair Day bring locals and tourists together for a parade down Main Street, games, food, and fun at the Bayside Park and, in the evening, fireworks.

Ken Sowles rides his antique bike in the Fourth of July Fair Day *c.* 1971.

Held the first weekend of February, the annual Colchester Winter Carnival provides a needed break for locals beginning to get cabin fever. Shown here is one of several indoor performances designed to entertain young and old alike.

Outdoor activities include sugar on snow, cross-country ski races, dogsled rides, horse-drawn hayrides, and much more.

Colchester's annual meeting is held on the Monday night before the first Tuesday in March. Voting on the budget and local public officials is done by Australian ballot the next day.

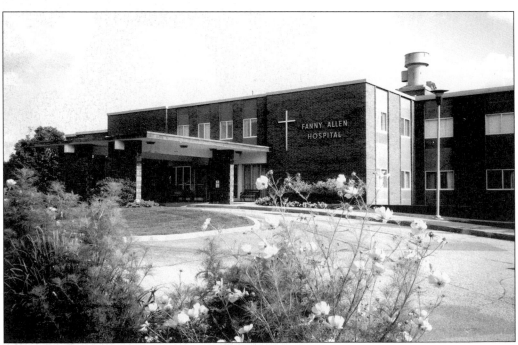

Pictured here is the Fanny Allen Hospital of Fletcher Allen Health Care, located on College Parkway.

Authorized in 1898 by the state legislature, a permanent campground was purchased in Colchester for the Vermont National Guard. The location, next to the U.S. Army's Fort Ethan Allen, allowed access to federal rifle ranges and assistance from federal troops. It was first called a "state reservation" and later named after a succession of governors until it became Camp Johnson in 1945. The year before, 1,193 men assembled to train together for the first time at the Colchester site. The camp expanded to 50 acres and facilities were improved between 1950 and 1955 (*Put the Vermonters Ahead: A History of the Vermont National Guard, 1864–1978*).

Adj. Gen. Martha Rainville was the grand marshal of the 2003 Fair Day parade. She is the first woman National Guard adjutant general in the United States.

New homes continue to spring up as Colchester becomes one of the fastest-growing towns in the state. (Courtesy of Julie Weaver and the Moorings Inc.)

Shown here is the white sandy beach of Niquette State Park in Clay Point.

Stables and horseback riding are everywhere you look on Middle Road in Colchester Village and in other parts of town.

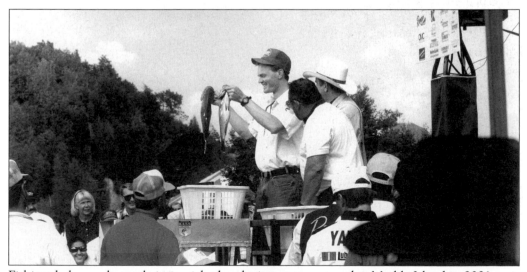

Fishing derby results are being weighed and winners announced at Marble Island in 2001.

The Hazelett Strip Casting Company is a locally owned, third-generation family business that opened its doors in Malletts Bay in 1956. Shown here is the Hazelett Twin-Belt Continuous Casting machine for the production of aluminum strip used for products such as building panels, roofing, rain gutters, and cooking utensils. The machines, assembled here, are shipped to all corners of the world. (Courtesy of D. Delmas and the Hazelett Strip Casting Company.)

Part of the Hilton franchise, this atypical Hampton Inn, at exit 16 off Route 89, has 188 rooms, some with extended-stay suites, a conference center, indoor pool, fitness center, and a restaurant. In the exit 16 area, there are several restaurants and two other national chain hotels.

In the fall of 2003, some 840 students entered Colchester High School, shown here. Colchester High School athletic teams are known as the Lakers. Their mascot is Champ, and their colors are blue and green.

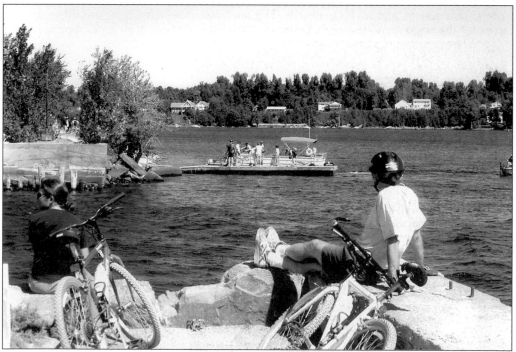

Cyclists await the Local Motion bike ferry that will take them over to the other side of the cut that separates Malletts Bay from the broad lake. Colchester's bike path will then connect to one on South Hero Island and lead up to Canada. The ferry was in a demonstration phase in August 2003.

The enchanting beauty of Malletts Bay and Lake Champlain is the town's mainstay.